IMAGES
*of America*

# AVON-BY-THE-SEA

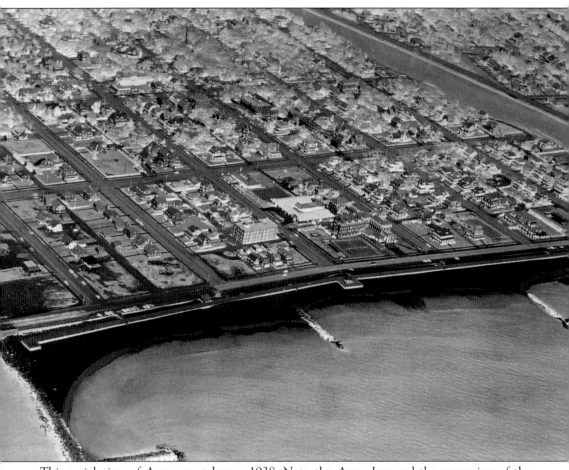

This aerial view of Avon was taken *c.* 1938. Note the Avon Inn and the expansion of the town since 1878, when it was purchased by Edward Batchelor. Avon-by-the-Sea had emerged as a resort that offered the best of good living. It was home to all who visited and lived there. (Courtesy of Jane Gannon.)

*This book is dedicated to the people of Avon:*

*To those who have passed with the ages and have left their mark,*
*to those of the present who remain constant in developing*
*and enhancing the growth of our town,*
*to those of the future who will continue to carry on the legacy, and*
*to Almighty God for the gift of Avon-by-the-Sea.*

IMAGES
*of America*

# AVON-BY-THE-SEA

Dolores Musante Gensch

ARCADIA
PUBLISHING

Published by Arcadia Publishing
Charleston SC, Chicago IL, Portsmouth NH, San Francisco CA

Printed in the United States of America

Library of Congress Catalog Card Number: 00-101920

For all general information contact Arcadia Publishing at:
Telephone 843-853-2070
Fax 843-853-0044
E-mail sales@arcadiapublishing.com
For customer service and orders:
Toll-Free 1-888-313-2665

Visit us on the Internet at http://www.arcadiapublishing.com

Note: In writing and compiling this book, my goal was to maintain authenticity when possible. However, the accuracy of the facts is contigent on available resources that may be incomplete.

Dolores Musante Gensch.

# CONTENTS

# ACKNOWLEDGMENTS

Without the help of the following people, this book would have stayed a dream instead of a magnificent reality. Thank you all.

To Governor Christine Whitman, whose letter to the citizens of Avon-by-the-Sea was gracious and inspiring. To Mayor Jerry Hauselt for his cordial letter and photographs. To Timothy M. Gallagher and his mother, Dorothy Gallagher, who were both a great help in verifying data and lending many photographs and copies of the *Avon Journal*. To Jane Gannon of Avon Realty, whose assistance was immeasurable and whose encouragement was a strong incentive for me. Her staff members, Arlene Lederle and Christella Fischer, were also there when I needed them. To Judy Silva and Michael Musante for proofreading the copy and making the necessary corrections. To Sheila McCarthy Watson, the town historian and director of the Avon Public Library, who avidly searched the library the town for photographs and books on Avon. To the Concerned Citizens of Avon, who were instrumental in initiating this project. To the Centennial Committee for being supportive and reaching out to the residents of Avon for photographs and postcards. To the Historical Editing Committee, Sheila Watson, Maureen Hinman, and Noel Winberry, president of Concerned Citizens of Avon, for their computer expertise and constant optimism. To my editor at Arcadia Publishing, Peter Turco, who was always a telephone call away when I needed his expertise and counseling.

And to the following group of enthusiastic citizens of Avon, whose love of Avon engaged them in this project. Also, lest I forget, my gratitude to those outside of Avon whose memories of Avon motivated them to donate photographs, postcards, and information: Olive Apicelli, Avon Baptist Church, Avon Coast Guard Station, Avon Library, Avon Methodist Church, Avon School, Bart Barry, Marion Berry, Boy Scouts of Avon Troop 89, Pat Buerck, Elizabeth Burbank, Marilyn Burns, Casagrande, Cashelmara Inn, Church of St. Elizabeth, Mildred Colyard, Concerned Citizens Committee, Aida D'Avella, Charles Dodd, Raymond Dodd, Scottie Franklin, Freehold Historical Society, Meghan Gannon Herrmann, Gianna Hair Salon, David Glovich Canvas Shop, Commissioner Joseph Hagerman, Postmaster Charles Hartl, Mr. and Mrs. Carl Ioniro, Rick Jones, Charlotte Kirk, Cathy G Klug, Mr. and Mrs. Charles Knubbert, Joann Langan, Daniel Lee, the Ligo family, Eileen McDermott, Peg McGovern, Florence Murday, Michael Murray, Betty Newman, Betsy Palmer, Marilyn Placitella, Eleanore Przygucki, Elizabeth and Larry Quinlan, Rev. Joseph Radomski, Dorothy Reibrich, St. John's Episcopal Church library, the Schneider family, Joe Skimmons, Isabel and Dick Smith, Marianne Stauch, Michael Stavitski, Officer Kevin Trochia, Tina Ventimilia, Ann Suchecki Wilhelmy, Phil Woodward, Betty S. Weeden, Hank Koch, Kenneth Child, and Anne Child. Last, but certainly foremost, to Ed , my husband, whose technical support helped me complete this book. If I have left any names out, please accept my apologies.

# INTRODUCTION

*Nels Avoné: The Legend*

> My brave son, when Greenland has lost its charms and natural possibilities for
> our people; when it becomes no longer easy for them to gather substances which
> give them nourishment, take them to Markland [America] that garden spot of the
> Gods of which I have told you.
> (Taken from Thomas J. Gagen's *History of Avon-by-the-Sea*.)

Soon after the death of his father, Nels Avoné and his tribes embarked on an adventurous
mission to the shores of a land that would bring survival to the Norsemen. Nels Avoné,
commander of the ship *Otter* and leader of the expedition, left the shores of his homeland
in Norway on April 9, 1027. Eleven ships began this perilous journey. Whether they would
survive the unknown waters or end their journey in the deep mysterious seas depended on
the gods.

After much sailing on the high seas, land was sighted. Truly, the gods had smiled upon them.
The journey had brought them to the shores of endless white sandy beaches. However, they
were not alone. Unbeknownst to them, Native Americans were peering through the bushes.
Meanwhile, Avoné had sent a scouting party to explore the area. Upon their return, Avoné and
his kinsmen were told of spring water, fish, game, and trees with fruit. The land was bountiful
and there was enough to sustain life.

The next day, they met the Native Americans on the shore. They were friendly and soon
harmony existed between the natives and the Vikings. But after several years, the Norsemen
became homesick and decided to return to Norway. The land had been named Avoné after
their courageous leader. The name was later shortened to Avon.

Thus ended the adventurous and heroic saga of Avoné and his Norsemen.

*The Giants of Avon*
When people speak of the land of Avon, they speak of the sandy beaches, the high elevation
above sea level, the opportunities for surfing, swimming, and fishing, and the beautiful aura of
the ocean. The resort area offers fine shops, hotels, bed and breakfast inns, places of worship,
restaurants, and more. But this virtual utopia might not have become a reality had it not been
for the talents of the people who helped make Avon-by-the-Sea the paradise of the New Jersey

coast. Many were involved in its growth and development. Some were leaders, and others were ardent followers. These men, Edward Batchelor, S. Thomas Penna, Robert Love, Alfred Sofield, and John Thomson, gave their all to Avon. One cannot fathom the talents they contributed to Avon's growth and development.

Having read several articles on Edward Batchelor, I became captivated by the mystique of the man. Not a single book that I perused had a photograph of Batchelor. After asking countless people, I was informed that there was a photograph in the clerk's office of the municipal court. On a snowy day in January, I went to the Municipal Building to investigate. I entered the clerk's office and saw that, indeed, Batchelor's photograph was prominently displayed. Under it was a brass plate that read, "Edward Batchelor, the Founder of Avon." Batchelor was the person who has been the most influential and most important factor in the history of Avon. His investment in Avon was one that resulted in the beautification and enhancement of a resort that was initially planned as a manufacturing town.

Batchelor was born on September 22, 1837. He was a native of Philadelphia and was the son of Sarah and William Batchelor. His father was English and his mother was the daughter of a colonial family who participated in the Revolutionary War. Edward went to school until he was 12 years old. Thereafter, he went to work earning $1 per week. Because of his ambition in business, he excelled and eventually became interested in tobacco growing and cigar manufacturing. He owned the largest cigar factory in Philadelphia. His place of business was located at 458–461 North Oranna Street in Philadelphia.

The present site of Avon-by-the-Sea was purchased by Batchelor in 1879 for $45,000. It was part of several tracts of land and was comprised of approximately 300 acres, embraced by Sylvan Lake on the north, Shark River on the south, and the Atlantic Ocean on the east. Batchelor began to sell the lots at a cost of $350. Each lot was 50 by 140 feet, and at the rear of each lot was a lane. The streets were adorned with native pine trees.

Batchelor's ambition led him even further. He erected the Avon Inn, which became the splendor of Avon. He built the Berwick Hotel, which is now the Columns. He built well-furnished cottages in the best architectural style.

Indeed, he was a giant of Avon. Although some saw him as a financial failure because he made some poor investments, his contributions to Avon were incredible. He donated his life and his personal fortune. He gave all he had to give. In 1925, Mayor John Thomson of Avon said that Batchelor "had given his all; he was a man of vision. He did not live to realize the wealth of his labor of love, but died brokenhearted because he thought he had failed." In reality, he had succeeded beyond all his expectations.

In 1897, due to a financial crisis, Batchelor lost the Avon Inn. He sold it at a sheriff's sale for $34,500. His loss was approximately $75,000. After Batchelor, several investors owned the Avon Inn. None of them, however, were successful. In June 1908, the inn was owned by Mrs. Obery, who received the property through a mortgage default. That same year, the Avon Inn was leased to a 24-year-old man named S. Thomas Penna. Several years later, Penna bought the inn from Mrs. Obery. With his knowledge and charisma, he was able to make it a "dream hotel." On Fifth and Sylvania Avenues, there existed the Home of the Merciful Savior, the Episcopal Mission for Crippled Children. It was raised up on wheels and timbers and pulled by cars, horses, and men to the location of the Avon Inn. The addition was attached, and the Avon Inn had a south wing. By this time the Avon Inn had 149 rooms.

Penna made interior and exterior improvements to the inn. A tennis court and a seascape garden were added. A stucco wall was built. Overall, Penna brought back the splendor of the Avon Inn. His professionalism was a reflection of his energetic personality. After he died in 1950, his two sons—S.T. Penna Jr. and John S. Penna—continued their father's legacy with the same success.

Edward Batchelor and S. Thomas Penna were pioneers of the Avon Community. They and others were responsible for enabling us to enjoy the fruits of their efforts. I hope that you enjoy this book and the chance to relive lost moments in Avon-by-the-Sea.

# One

# BY THE SEA

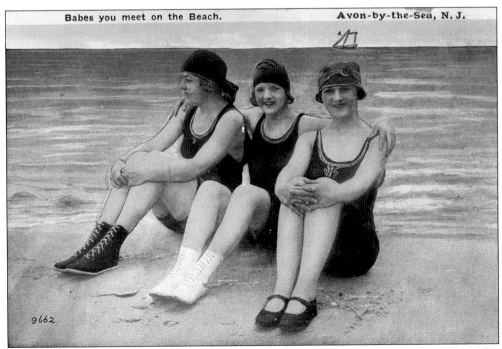

"Babes you meet on the beach" in Avon-by-the-Sea pose at the shoreline in the 1930s. The swimsuits are a bit provocative for the time, sending enticing messages to future vacationers. Shoes were a regular part of the bathing costume and were used to protect feet from the shells on the ocean floor and from the heat of the sand. (Courtesy of Tina Ventimilia.)

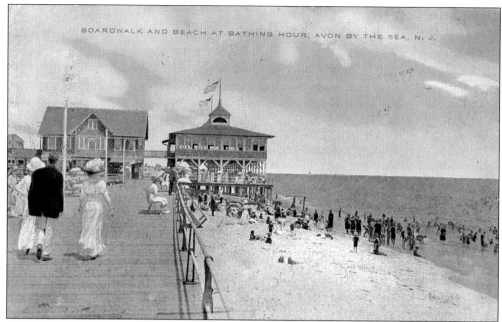

This postcard, dated 1915, depicts the popular pastime of "walking the boards" while others sunbathe. The pavilion was the only building on the beachfront as far back as 1883. It was built by Edward Batchelor and later run by Robert C. Love for many years. The boardwalk, bathhouse, and the Avon pool were added after 1888. (Courtesy of Michael, Avon Pharmacy.)

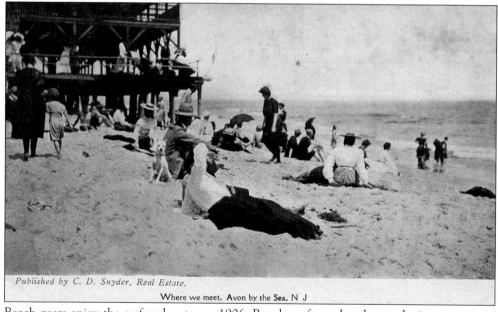

Beach-goers enjoy the surf and water, c. 1906. Benches of wood and wrought iron were now provided on the Boardwalk promenade by the borough for those who wished to relax on the waterfront. (Courtesy of Michael, Avon Pharmacy.)

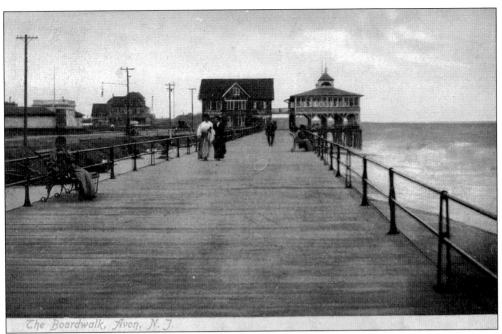

This *c.* 1900 view looking north shows the Casino and Pavilion connected by a walkway. The signature lamps on the boardwalk are yet to come. (Courtesy of Jane Gannon.)

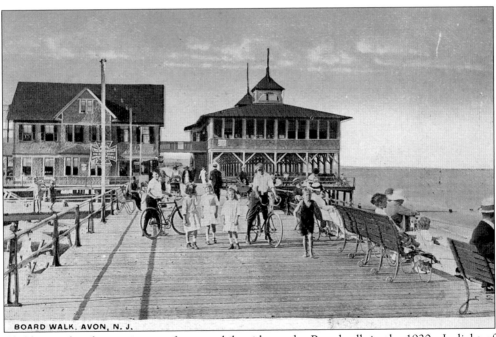

Children in knickers enjoy an afternoon bike ride on the Boardwalk in the 1920s. In light of the crowded benches, ocean gazing was a popular way to spend a summer afternoon. (Courtesy of Michael, Avon Pharmacy.)

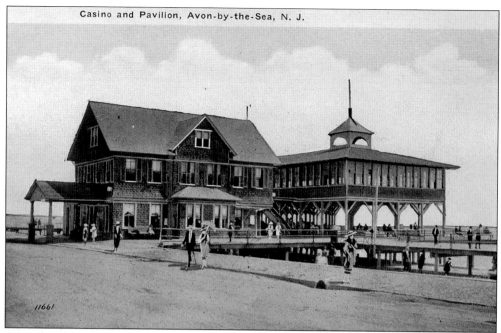

11661

According to *William Nelson's History of the New Jersey Coast in Three Centuries,* "on the beach there was one of the best and most complete pavilions on the coast, having bathrooms on the first floor and a fine space above for sitting, dancing, and roller skating." (Courtesy of Tina Ventimilia.)

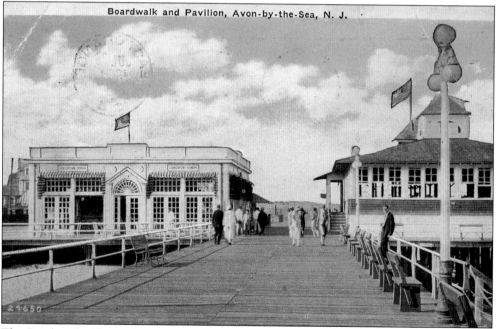

27650

The Pavilion has been renovated numerous times since the days of Key East. In 1920, the walkway connecting the two buildings was removed, leaving the building on the left as a food concession and a comfort station while the pavilion on the right was used for social events. (Courtesy of Jane Gannon.)

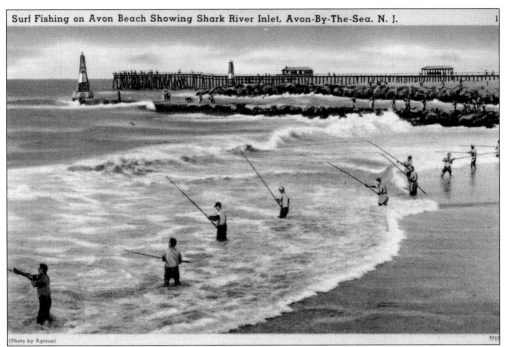

(Photo by Agreen)

Fishing has been one of the main attractions of Avon since the late 1800s. In this *c.* 1900 postcard, fishermen are surfcasting for striped bass, bluefish, and flounder. Shark River Inlet can be seen in the background. By 1888, the New York City fish markets received more seafood from the Shark River area than from any other location. (Courtesy of Michael, Avon Pharmacy.)

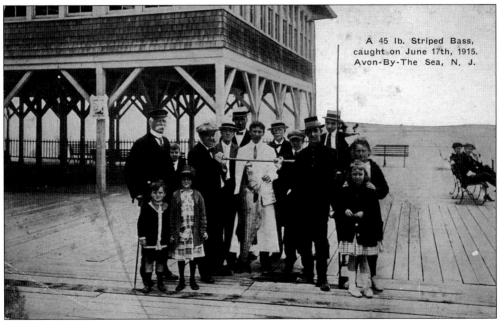

A 45 lb. Striped Bass, caught on June 17th, 1915. Avon-By-The Sea, N. J.

On June 17, 1915, proud anglers exhibited their prize catch—a 45-pound bass caught from the surf. (Courtesy of the Avon Library Collection.)

13

Sailboats in 1945 were allowed easy access to the ocean from the Shark River Inlet and the Belmar Marina. (Courtesy of Michael, Avon Pharmacy.)

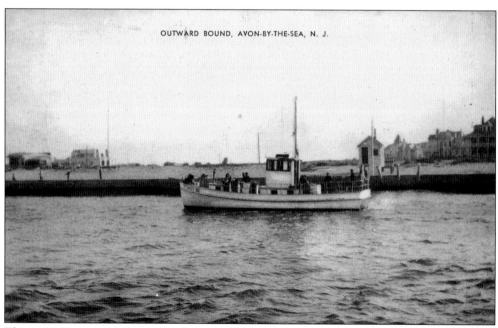

This *c.* 1940 postcard shows the *Optimist III*, which was owned by Charles Dodd. Dodd was among the first to operate a fishing "party boat" from Avon. Dodd's boat was one of the first to dock at the Belmar Marina. (Courtesy of Jane Gannon.)

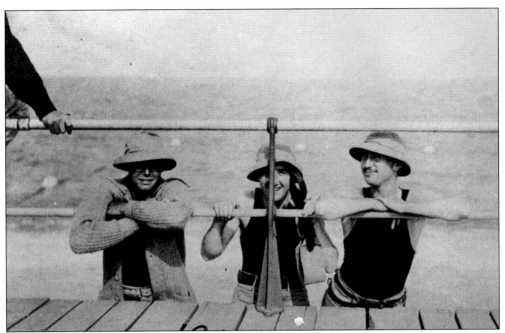

This 1912 photograph of three unidentified lifeguards shows that even though the beaches were protected, it was not until an ordinance in 1929 that the borough legally provided guarded bathing. (Courtesy of Tim Gallagher.)

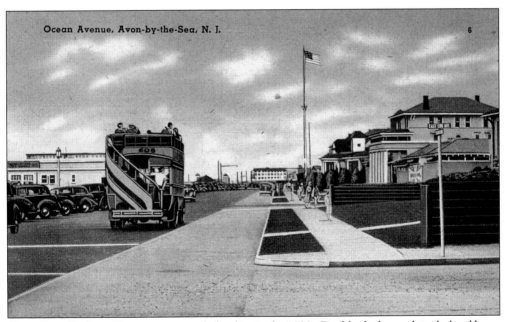

Ocean Avenue, Avon-by-the-Sea, N. J.

Coast Cities Railway Company operated a bus line in the 1930s. Double-decker and single-level buses were routed along Ocean Avenue from Asbury Park to Sea Girt. (Courtesy of Jane Gannon.)

This 1934 postcard was taken from the Belmar side of the Shark River Inlet. It illustrates the popularity of river swimming at the time. (Courtesy of Tina Ventimilia.)

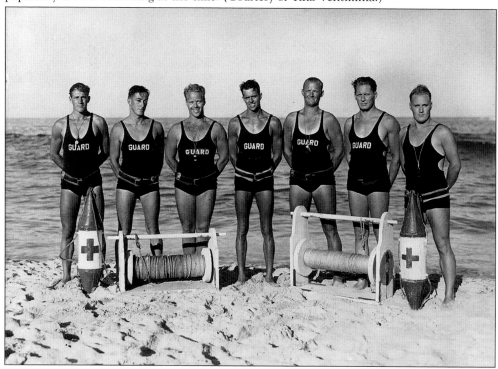

Avon lifeguards prepared for duty in the 1930s. They are, second, fifth, and seventh from the left, Jim Kirk, Milt Hampton, and Tom Child. (The others are not identified.) Tom Child was the lifeguard captain at the time. (Courtesy of Anne Child.)

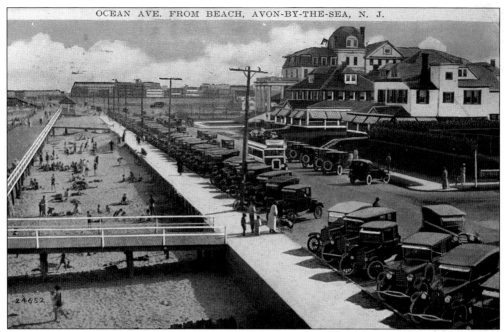

In the 1930s, bathers could enjoy both sides of the promenade. A tennis court was located directly across the walkway on Ocean Avenue. When the tennis court was removed, it became a play area for the children of Avon known as "Bunker Hill." (Courtesy of Jane Gannon.)

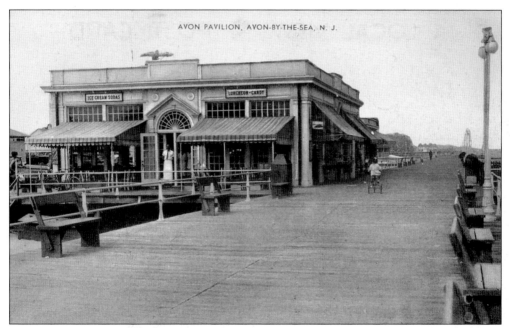

AVON PAVILION, AVON-BY-THE-SEA, N. J.

The Pavilion has changed owners many times. In the 1930s, it was leased by the Petersons, who ran a food concession and a candy shop that specialized in saltwater taffy. The benches shown in this postcard had reversible seats that could face the ocean or the boardwalk. (Courtesy of Michael, Avon Pharmacy.)

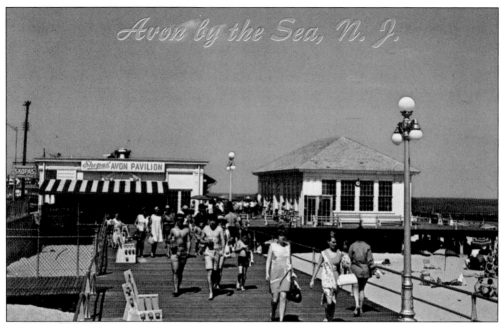

The Skopas family took over the Pavilion in the 1950s and expanded the menu, which then included breakfast and lunch. They specialized in homemade ice cream, orangeade, and lemonade. (Courtesy of Jane Gannon.)

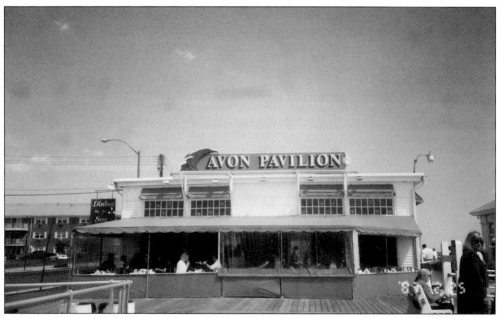

The Hutchinson family was operating the Pavilion by the late 1970s. They renamed it Scottie's Avon Pavilion. Under the present lease, Rob Fishman operates what is now called the Avon Pavilion as a full-service gourmet restaurant with a takeout counter. (Courtesy of Ed Gensch.)

Madge Dodd, left, Charles Dodd's mother, poses with a friend in the summer of 1915. Madge Gouldy Dodd died at the age of 100. She was a lifelong resident of Avon. (Courtesy of Raymond Dodd.)

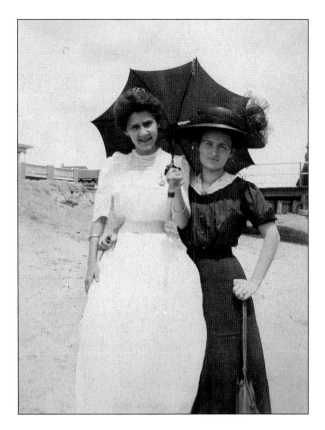

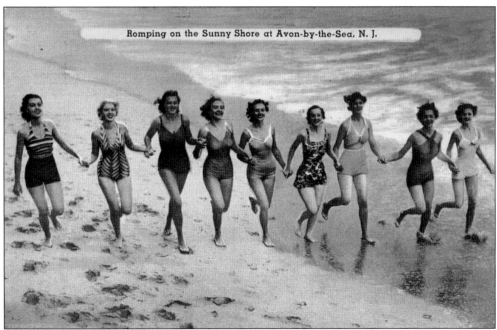

Romping on the Sunny Shore at Avon-by-the-Sea, N. J.

This "romping on the sunny shore" postcard from 1943 shows that Avon was still a vibrant vacation spot during World War II. (Courtesy of Jane Gannon.)

Trophies were awarded to the winners of the annual Baby Parade in this July 23, 1965 photograph from the *Asbury Park Evening Press*. Shown are, from left to right, the following: (foreground) Palma Ioniro, Cutest; Jodi Tagliarini; (background) Jodi's brother Terry, Most Original; and twin brothers Glen and Craig Suchecki, Funniest. (Courtesy of Mrs. Carl Ioniro.)

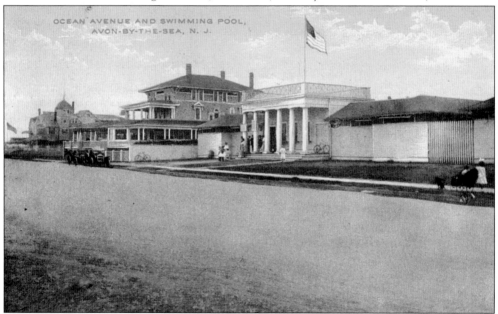

The Avon pool was a great attraction for both visitors and residents as far back as 1914. Swimsuits were available for rent, and lockers with shower facilities could be rented for the day. (Courtesy of Michael, Avon Pharmacy.)

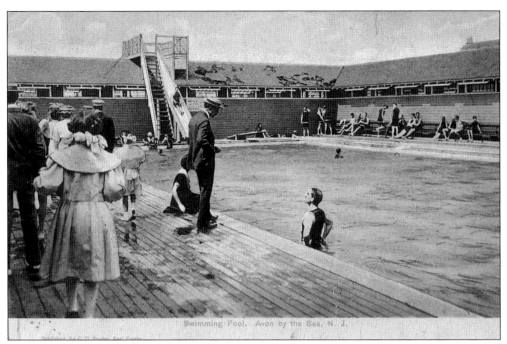

The pool is shown in 1907, when it would be filled with saltwater each day and emptied each evening. Employees would scrub the bottom of the pool with an acid cleaner before refilling. (Courtesy of Tina Ventimilia.)

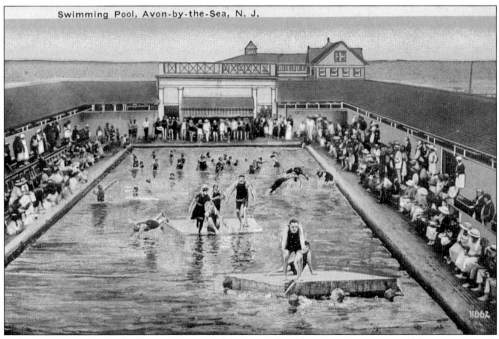

Swim races and water ballets were annual events where Avon swimmers would compete with Bradley Beach. (Courtesy of Tina Ventimilia.)

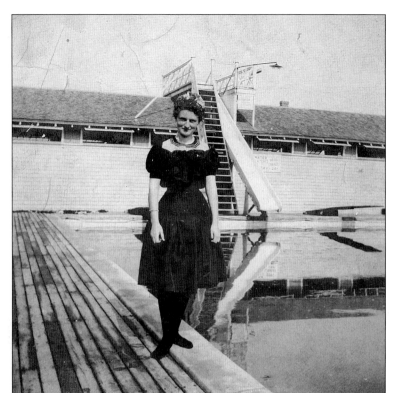

Madge Dodd was the cashier at the Avon pool during the early 1900s. The slide that came from the roof was removed by the 1920s. (Courtesy of Raymond Dodd.)

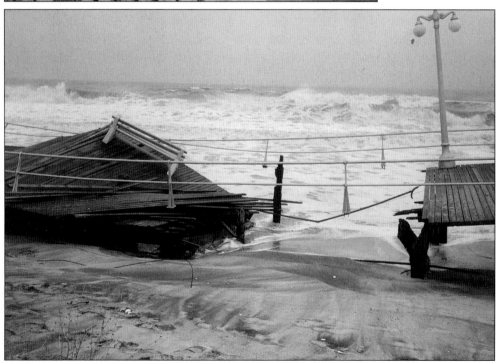

On December 11, 1992, a northeaster storm destroyed the boardwalk. Wave heights reached 20 feet and winds topped at 100 miles per hour. (Courtesy of Ed Gensch.)

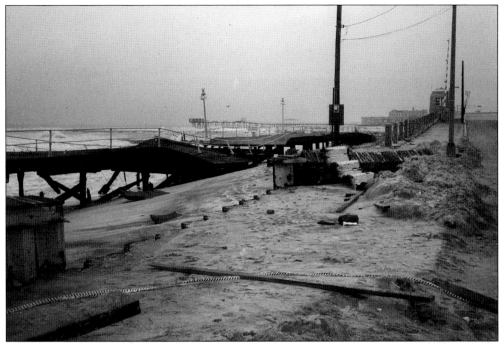

The storm has been compared in strength to the northeaster storm that devastated New Jersey in 1962. The Avon Police and Fire Departments worked for 36 hours without stopping, evacuating residents and providing emergency patrol. (Courtesy of Ed Gensch.)

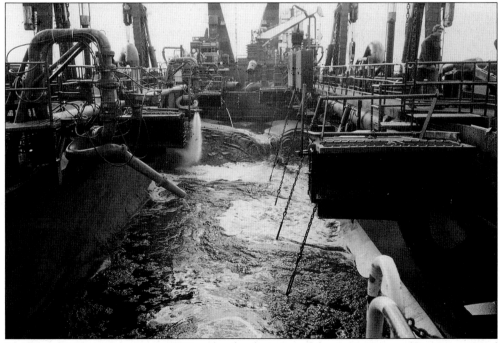

Beach replenishment began in 1999 under the direction of the Army Corps of Engineers. Sand was pumped on to the beachfront from a barge. The project restored miles of beachfront from Asbury Park to Spring Lake. (Courtesy of Mayor Jerry Hauselt.)

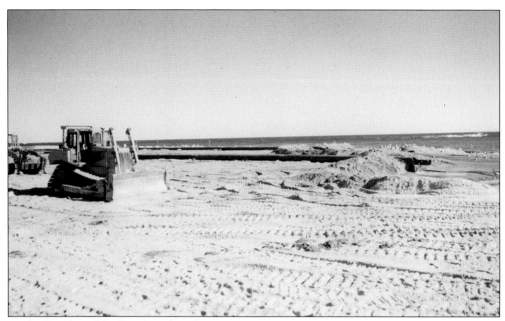

By the last day of the beach replenishment project, 200 feet of sand was added to the shoreline. (Courtesy of Mayor Jerry Hauselt.)

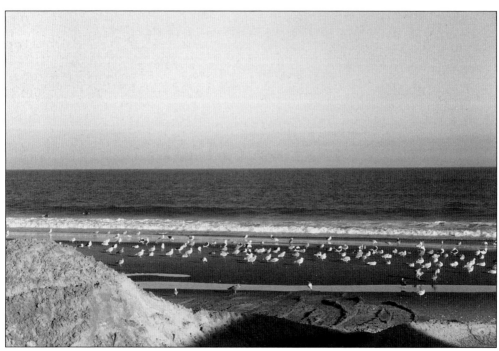

Seagulls enjoy a winter afternoon on the enlarged beachfront. (Courtesy of Ed Gensch.)

## Two

# THE AVON INN

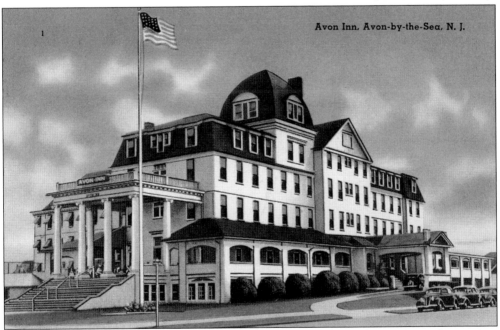

Contradicting the legend of Nels Avoné, the following was reported in the June 30, 1899 *Asbury Journal* on how Avon received its name: "The Managers of the Avon Inn are a Mr. Cranston who was formerly the proprietor of the New York Hotel, New York City and a Mr. Hand who had formerly managed the Hotel Marlboro of New York City. Avon derived its name from the birthplace of Shakespeare, and in the preparation of the menu card the management did not lose sight of this fact. The guests were permitted to enjoy a feast for the mind as well as the body. Every course mentioned on the card was preceded by an appropriate quotation from some noted poet, Shakespeare being the most freely quoted." (Courtesy of Tina Ventimilia.)

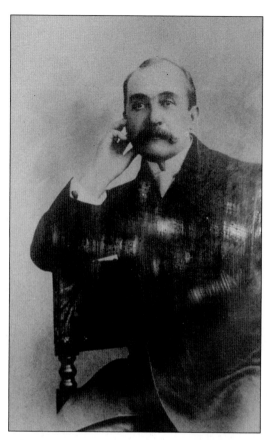

Edward Batchelor, the "founder of Avon," built the Avon Inn at the cost of $79,000. His dream to build the finest, most luxurious palace on the Jersey shore became a splendid reality. He was responsible for a structure that was superior to any other on the New Jersey coast. (Courtesy of the court clerk's office, Avon.)

According to the March 17, 1886 *Key Note*, taken from T. Gagen's book, "Avon Inn is one of the finest hotels on the New Jersey Coast. It is about 255 feet long and from 40 to 50 feet wide, of five stories. It has 149 rooms, all fitted up with all the modern improvements which skilled architects could suggest and money could purchase. Radiators are in all the rooms, and a force of live steam at hand to prevent dampness from entering the house. Wide halls and stairways with easy steps, besides one of the Stokes and Parish improved elevators, make all parts of the house accessible. Spacious verandahs surround the house." (Courtesy of Jane Gannon.)

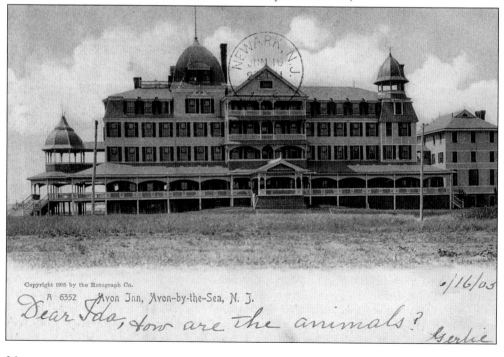

Copyright 1905 by the Rotograph Co.

A 6352   Avon Jnn, Avon-by-the-Sea, N. J.

Dear Ida, how are the animals?

Gertie

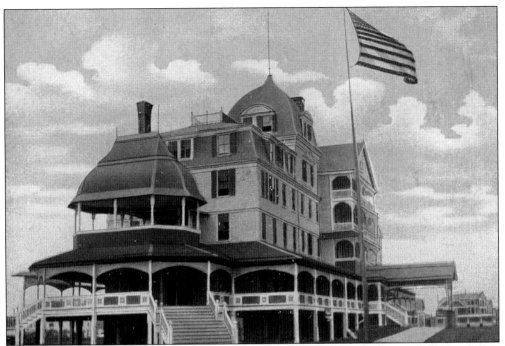

The structure of the Avon Inn was modeled after a traditional English inn and had all the conveniences of an opulent hotel. Additional rooms had been added and improvements were continually being made. (Courtesy of Michael, Avon Pharmacy.)

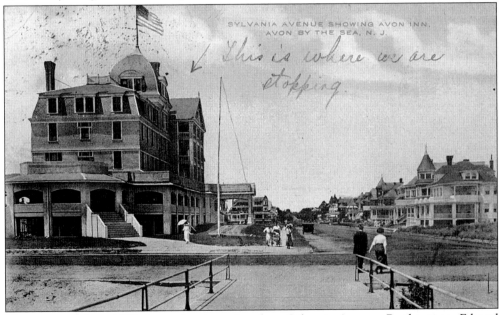

This postcard from 1912 shows the Avon Inn from Sylvania Avenue. By this time, Edward Batchelor had lost the Avon Inn, having been forced to sell it for a second time at a sheriff sale for $34,500. Other investors of the Avon Inn were not successful, until S. Thomas Penna leased it in 1908. Seven years later, he would own the Avon Inn. (Courtesy of Michael, Avon Pharmacy.)

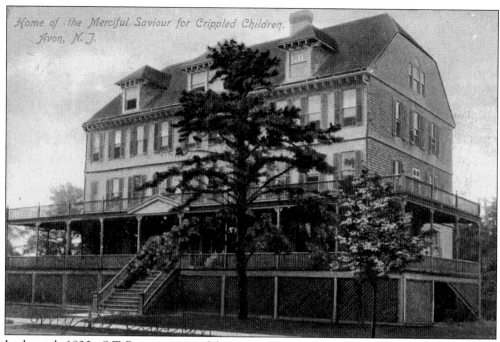

In the early 1920s, S.T. Penna, owner of the Avon Inn, added 45 rooms by attaching an existing building to it. The Home of the Merciful Savior for Crippled Children was raised on wheels and pulled by men, horses, and cars to the Avon Inn. (Courtesy of Tina Ventimilia.)

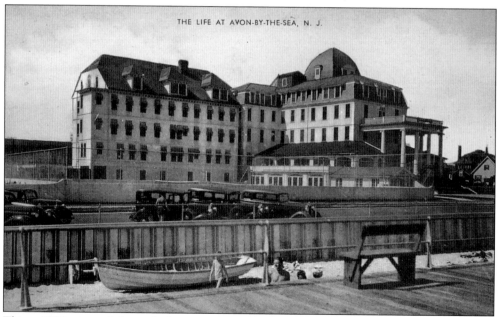

This *c.* 1920 postcard shows the home semi-attached to the Avon Inn. If one looks between the two buildings, a division can be seen. (Courtesy of Jane Gannon.)

In 1908, S. Thomas Penna leased the Avon Inn from Mrs. Obery. Seven years later, he owned it, making many improvements, including the addition of a tennis court and gardens. During the 1920s, the two-story columns facing the ocean were built. He also added a brick stairway on the oceanfront. Besides running the hotel, Penna served as the mayor of Avon for two terms. (Courtesy of the Avon Library.)

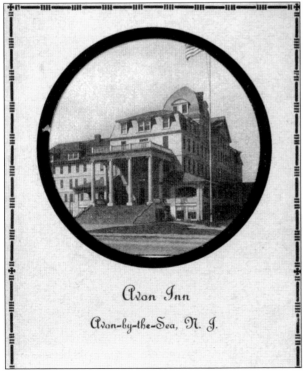

Avon Inn

Avon-by-the-Sea, N. J.

Mr. Penna put out an announcement stating he was opening the inn for the summer season. Improvements had been made and the Avon Inn was opened to selected clientele. This photograph also shows the announcement that was distributed to prospective vacationers. The hotel occupied an entire block on the oceanfront and offered many luxurious accommodations. This image dates to the late 1920s. (Courtesy of Dorothy Gallagher.)

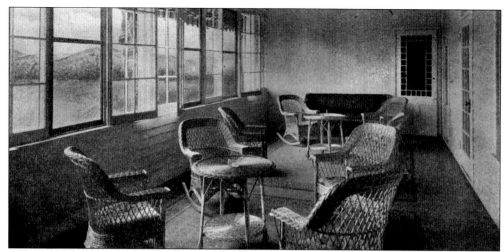

The Avon Inn had much to offer its patrons. The sun parlor pictured on this postcard enabled clients to converse and still enjoy the view and warm rays of the sun. It had an unobstructed view of the ocean. (Courtesy of Dorothy Gallagher.)

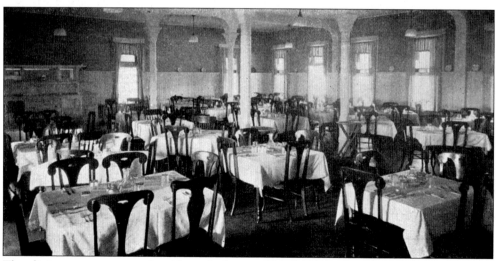

The dining room was comfortable and elegant. The kitchen provided a special menu for children. The table service was impeccable. There was also a diet kitchen for guests who wished to prepare special food for themselves. (Courtesy of Dorothy Gallagher.)

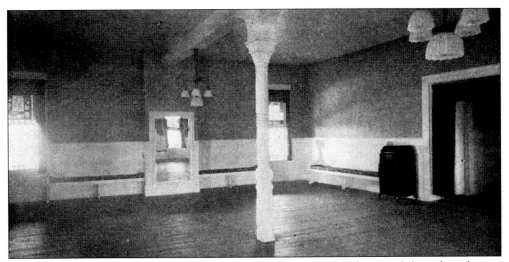

The ballroom featured dances every evening except Sunday. It has been said that when the inn was closed during some winters, S. Thomas Penna would allow children from Avon to roller-skate on the ballroom floor. (Courtesy of Dorothy Gallagher.)

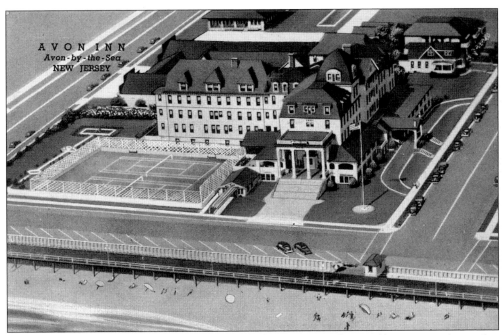

The inn had a tennis court in the 1920s and also access to three golf courses within a few minutes from the hotel. It was a summer resort that lacked nothing. The guests were pampered with the best of everything. (Courtesy of Jane Gannon.)

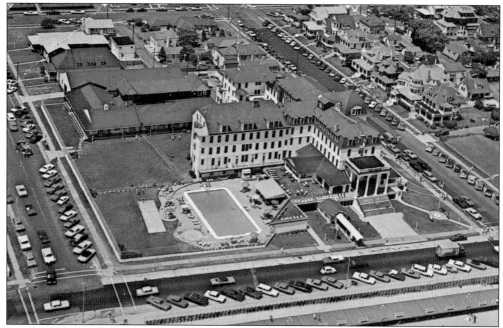

An aerial view of the Avon Inn shows the splendor of the hotel. It catered to many prominent clients. It played host to the Rockefellers, the Wanamakers, and the Goulds. Many of the "400" found the cuisine and ocean front irresistible. In the 1940s, a pool was built in place of the tennis court. The tennis court was moved to the rear of the hotel. (Courtesy of Jane Gannon.)

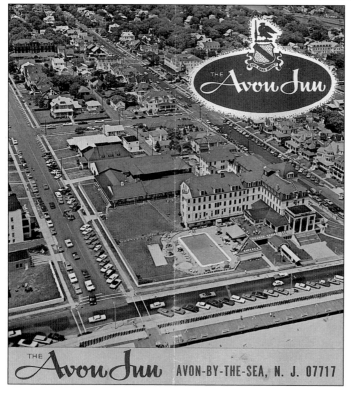

In the 1950s, a new brochure was printed for the hotel. More improvements were added. Air-conditioned public rooms were available. The excellent cuisine and gracious hospitality still existed. After S. Thomas Penna died in 1950, his two sons, John and S. Thomas Penna Jr., were determined to carry on the splendor of the Avon Inn. (Courtesy of Ann Suchecki Wilhelmy.)

The main lobby welcomed guests. Comfortable and warm, its décor was skillfully enhanced by its modernization. (Courtesy of Ann Suchecki Wilhelmy.)

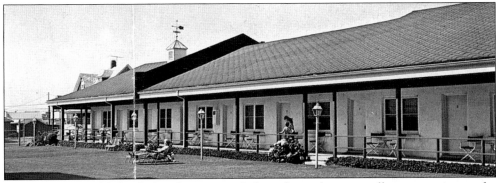

The Avon Inn added a lodge that operated throughout the year, offering vacationers the opportunity to enjoy all four seasons while still affording privacy. At one time, the lodge rates, which included continental breakfast, were as follows: $10 double-occupancy for the first two nights, $8 each additional night; $6 single-occupancy for the first two nights, $5 each additional night; $2 each additional person. In 1959, the Riptide Room was added to the Avon Inn. This gave the hotel a second dining area. The Riptide Room offered excellent cuisine. Complete dinners ranged from $3 to $6. Sandwiches were 50¢, and platters were $1.50. Unique entertainment programs were performed every Wednesday during the summer. However, in 1978 the motel-lodge was the only section open for business. By the 1970s, the inn had fallen on hard times and was closed. (Courtesy of Ann Suchecki Wilhelmy.)

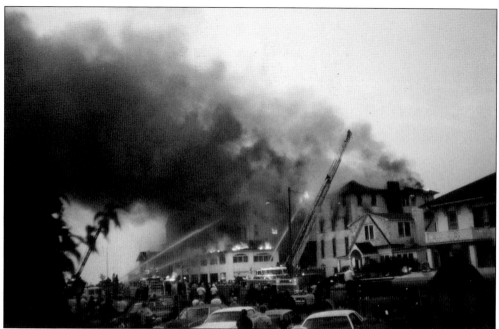

Deputy Fire Chief Tom Child responded to a call in the early morning of Thursday July 20, 1978. A fire had been reported in the rear of the Avon Inn. As the firefighters arrived, the "windows throughout the rear of the structure blew out showering the street with glass. With the rush of fresh air the flames spread rapidly through the building toward the main hotel." (Taken from a report by Ken Child.) This photograph was taken from Sylvania Avenue. (Courtesy of Phil Woodward.)

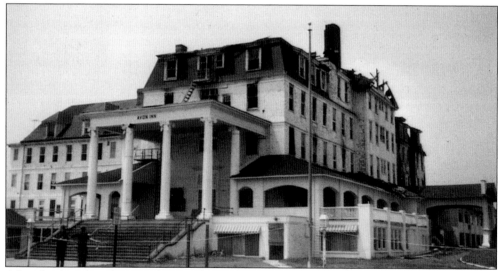

After the fire, this photograph was taken from Ocean Avenue. Note that the columns appear to have little damage. Their majesty is still evident. The red and white awnings are still vibrant in color. The entrance does not appear to have extensive damage. Heavy fire-fighting efforts to the south wing had been successful. Flames were prevented from spreading into this section of the building. Unfortunately, the upper floors were destroyed because mattresses had been stored in the attic. (Courtesy of Phil Woodward.)

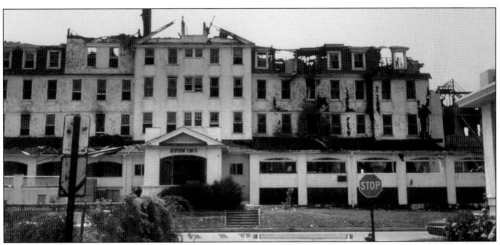

Because of the extent of the fire, water had become scarce. A decision was made to tap the largest basin of water available: the Atlantic Ocean. "At 7 a.m. the fire was declared under control and units began to take up. The Avon firefighters, however, remained on the scene until noon on Friday, July 21 more than 32 hours after the first unit responded." (Taken from a report by Ken Child; photograph courtesy of Phil Woodward.)

## *Roll Call for the Avon Inn Fire, July 20, 1978*

| Company | Engines | | Ladders | AMB | Rescue | Personnel | | Time |
|---|---|---|---|---|---|---|---|---|
| Disp. | | | | | | | | |
| Avon | 2 | | 1 | 2 | 1 | 61 | | 0338 |
| Nept. City | 2 | – | | 2 | 2 | 65 | | 0342 |
| Belmar | 2 | | 1 | 1 | 1 | 53 | | 0345 |
| Brad Bch. | 3 | | 1 | 1 | 1 | 50 | | 0349 |
| Ocean Grove | 2 | | 1 | 1 | | 15 | | 0400 |
| Neptune | | | | 4 | | 105 | | 0415 |
|    Unexcelled | 2 | | 1 | | | | | |
|    Hamilton | 1 | | | | | | | |
|    SRH | 1 | | | | | | | |
|    Liberty | 1 | | | | | | | |
| Spring Lake | 1 | | | 1 | | 23 | | 0445 |
| Sea Girt | 1 | | 1 | | | 18 | | 0445 |
| Manasquan | 1 | 1 | | 1 | | 25 | | 0500 |
| West Belmar | 2 | | | | 1 | 33 | | 0500 |
| South Wall | 2 | | | | | 14 | | 0500 |
| Glendola | 1 | | | | 1 tanker | 7 | | 0500 |
| Wanamassa | 1 | | | 1 | | 20 | | 0500 |
| Oakhurst | 1 | | | | | 21 | | 0500 |
| So. Belmar | 1 | | | 1 | | 13 | | 0630 |
| USCG | 1 41' boat | | | | | 10 | | 0515 |
| Mon. Cty Fire Police | | | | | | 12 | | 0350 |
| Mon. Cty. Radio | | | | | | 2 | | 0415 |

Above are all the names of the fire companies that assisted on that fateful day when the Avon Inn was destroyed by fire. Five hundred and forty-seven firefighters from 23 companies responded to the call. (Courtesy of Ken Child.)

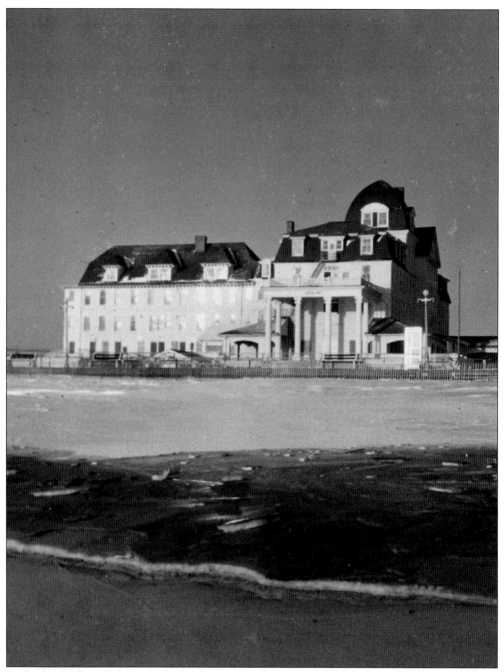

In the late 1920s, the Avon Inn was the gateway for the growth and development of Avon-by-the-Sea. It was now a mere shadow of the splendor it once had as one of the most luxurious hotels on the New Jersey coast. (Courtesy of Tina Ventimilia.)

# *Three*

# THE GUEST HOUSES

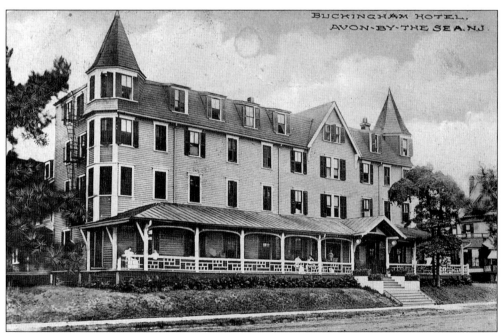

The Buckingham Hotel, c. 1913, was located on the northeast corner of Sylvania and Second Avenues and was completed in 1890. It boasted first-class accommodations and wide verandahs with fine ocean and river views. The building was surrounded by pine trees. The MacDowell brothers were the first owners. (Courtesy of Jane Gannon.)

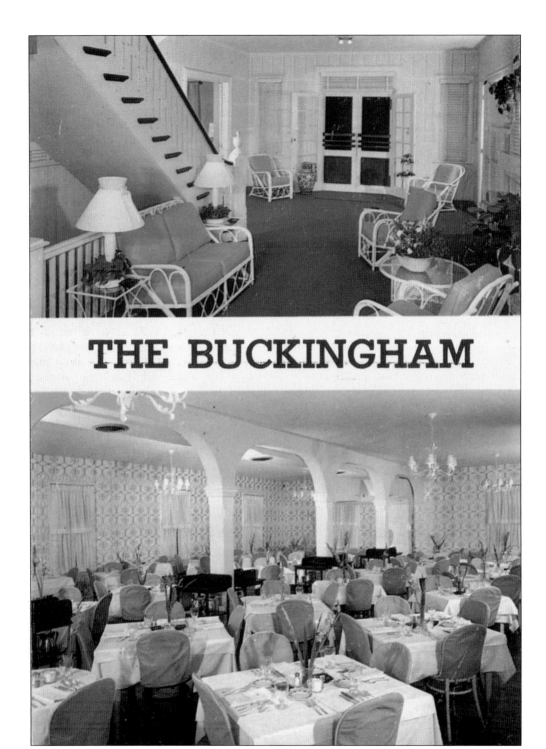

The lobby of the Buckingham Hotel (top) was furnished in wicker and rattan during the 1940s. The staircase led to the 70 guest rooms. Both the lobby and dining area (bottom) are shown in the heyday of the Buckingham Hotel. The hotel offered fine food, dancing, and entertainment during the season. (Courtesy of Tina Ventimilia.)

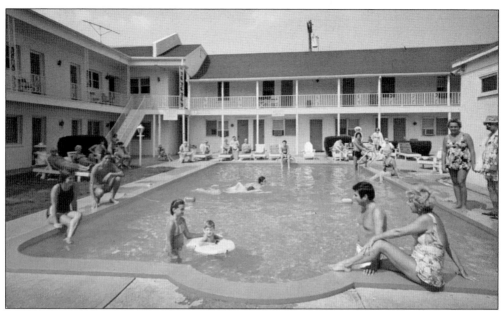

The Buckingham Hotel, like the Avon Inn, later added a motor lodge to accommodate the seasonal overflow. The motel rooms surrounded the newly added pool area. After many failed attempts to revive the business, the owners sold the building to the borough. In 1994, the hotel was demolished and the property was divided into five lots. By early 2000, five new homes were under construction. (Courtesy of Jane Gannon.)

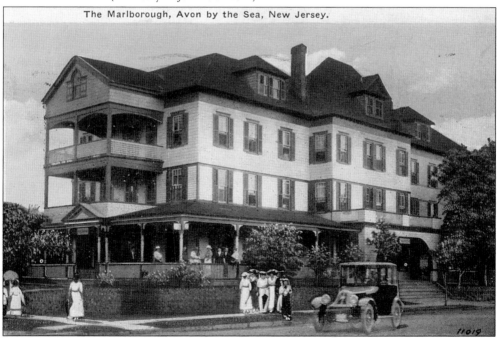

The Marlborough, Avon by the Sea, New Jersey.

The Marlborough Hotel was built in 1888 and located on the southeast corner of Norwood and Second Avenues. It was build by Dr. Albert Turner, a leading New York physician who had originally hoped to make the entire block into a health resort. (Courtesy of Michael, Avon Pharmacy.)

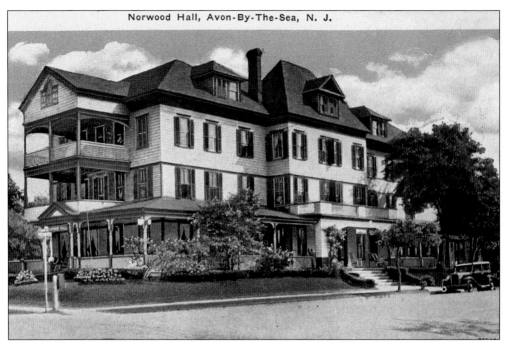

The Marlborough Hotel became the Norwood Hall around 1935. Few changes were made to the 50 guest rooms. The decks on the Norwood Avenue side offered views of Sylvan Lake and the ocean two blocks away. (Courtesy of Tina Ventimilia.)

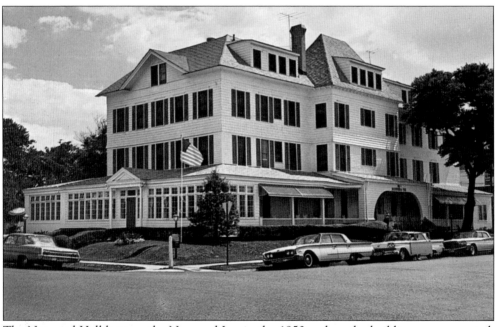

The Norwood Hall became the Norwood Inn in the 1950s, when the building was renovated. A swimming pool for guests was added, and several of the rooms were equipped with private baths. The Norwood Inn is still in operation from May 1 to November 1. (Courtesy of Michael, Avon Pharmacy.)

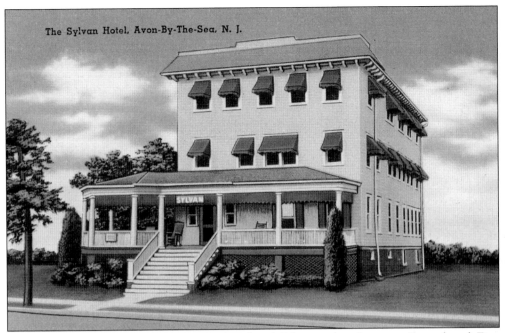

The Sylvan Hotel, Avon-By-The-Sea, N. J.

The Sylvan Hotel, located on the south side of Sylvania Ave between Second and First Avenues, was one of the smaller hotels in the borough, offering a home-style stay for summer visitors. (Courtesy of Michael, Avon Pharmacy.)

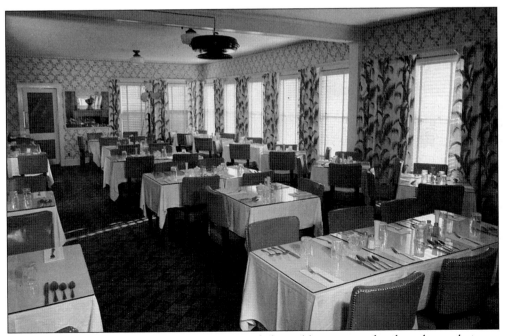

The Sylvan Hotel offered dining to guests and the public, serving family-style meals in an upscale atmosphere. (Courtesy of Michael, Avon Pharmacy.)

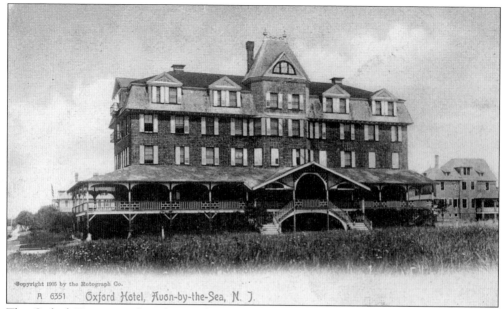

The Oxford House stood at the northwest corner of Second and Garfield Avenues. It was erected in 1888 and was furnished from the grand depot of John Wanamaker. The hotel had 70 rooms. By the 1920s, it was illuminated throughout by electricity and had hot and cold running water in each of the bedrooms. (Courtesy of Michael, Avon Pharmacy.)

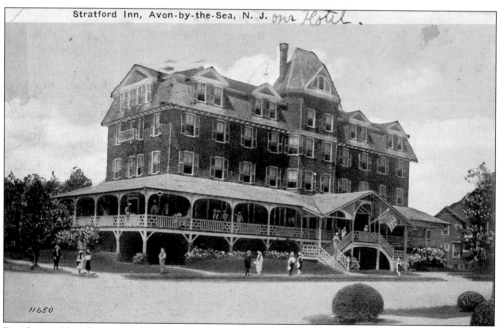

By the 1920s, the Oxford House became the Stratford Inn to honor the memory of the Shakespearean theater on the River Avon. The English names given to all of the hotels certainly uphold the theory that Avon was named for that body of water. The Stratford offered a tennis court, a pine grove for young visitors, a wide verandah, and fine dining. (Courtesy of Tina Ventimilia.)

42

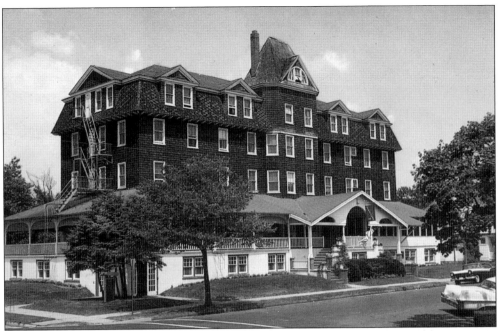

This postcard was probably the last one made of the Stratford Inn. The inn operated through the 1960s with a popular bar that had headline entertainment. In April 1974, the Stratford Inn was demolished and four homes were built on this site. (Courtesy of Tina Ventimilia.)

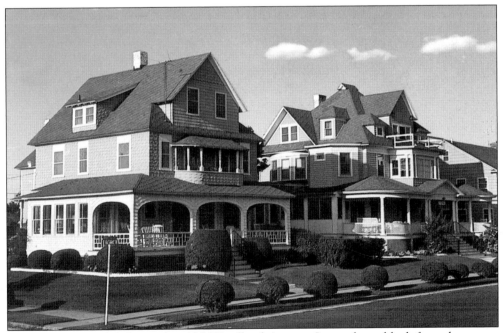

The Victoria Hotel, left, stood at 105 Woodland Avenue. Located one block from the ocean, it advertised for "select clientele." The Victoria as well as other guest houses and hotels offered summer employment to many Avon residents as chambermaids, bartenders, waitresses, and desk clerks. (Courtesy of Tina Ventimilia.)

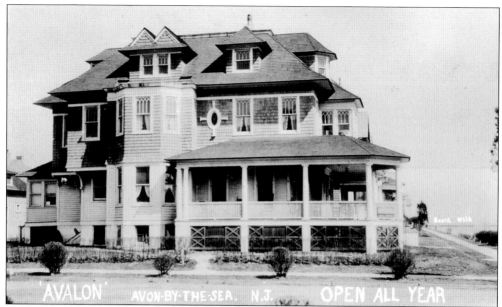

The Avalon Hotel was located at 46 Sylvania Avenue on the northeast corner of Sylvania and First Avenues. It was erected in 1912 by Thomas O'Reilly, who lived there until 1922. Today it is a private residence. (Courtesy of Tina Ventimilia.)

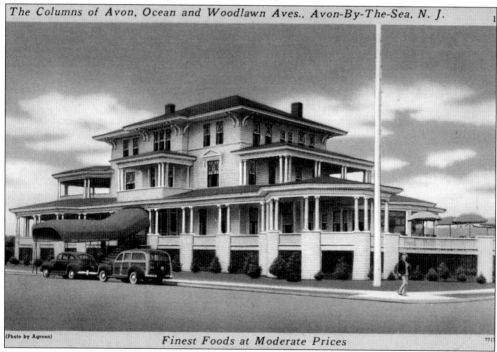

*The Columns of Avon, Ocean and Woodlawn Aves., Avon-By-The-Sea, N. J.*

(Photo by Agreen)    *Finest Foods at Moderate Prices*

The Berwick Lodge, later known as the Columns, stood on the corner of Woodland and Ocean Avenues. It was built in 1883 and operated as a small hotel until 1902, when it was remodeled into a mansion. It was rumored that the actor Victor Mature was a summer gardener here in his teens. By the 1920s, it was once again operating as a hotel with 32 sleeping rooms. (Courtesy of Michael, Avon Pharmacy.)

The dining room of the Columns was elegant and served complete seafood dinners for $5 in the 1940s. The name for the hotel comes from the 74 columns located in and out of the building. The hotel still attracts many visitors for summer dining and nightlife. (Courtesy of Jane Gannon.)

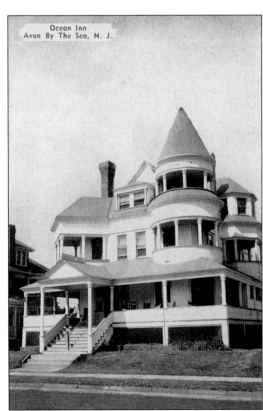

The Ocean View Inn was located on Sylvania Avenue across from the Avon Inn. Today, it is a private residence. In the 1940s, it operated as a small hotel with nine bedrooms that featured open fireplaces, a library, and a dining room. (Courtesy of Jane Gannon.)

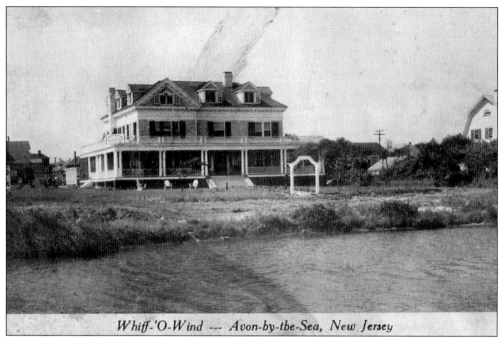

*Whiff-'O-Wind --- Avon-by-the-Sea, New Jersey*

The Whiff O' Wind, shown *c.* 1920, was originally built as a summer residence of William G. Wilcox, a prominent statesman. It faces Sylvan Lake and has views of the Atlantic Ocean. It was restored in 1985 as the Cashelmara Bed and Breakfast Inn. (Courtesy of the Cashelmara.)

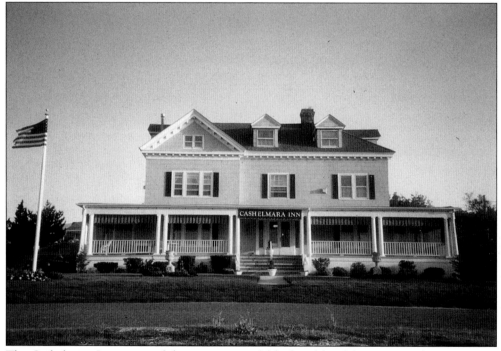

The Cashelmara Inn is one of the more successful bed and breakfast inns on the New Jersey coast. The rooms are furnished with antiques that give an authentic Victorian feel to the house. Cashelmara in Gaelic means "big house by the sea."

In the 1880s, One Main Street was known as the Riverside Hotel. The location on the Shark River offered easy access to the ocean, the Belmar Marina, and Main Street shopping. The proprietor was Mr. Edward Brand. Today, it is the home of Divers II, a scuba diving equipment shop managed by Joe Skimmons and Kevin Quinn. (Courtesy of Scottie Franklin.)

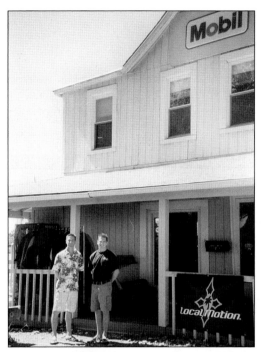

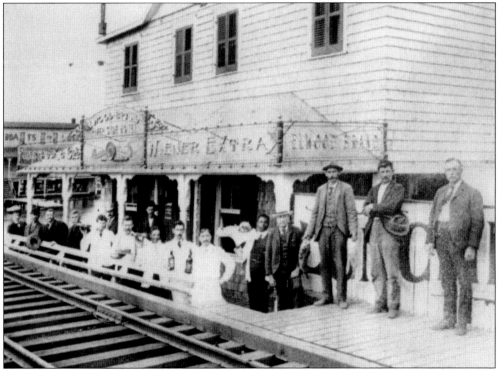

This group shot in front of the Riverside Hotel shows its customers and staff. A close examination of the photograph reveals that one of the bartenders is holding a bottle of whiskey, rumored to have been painted in after the photograph was developed. The trolley tracks that ran down Main Street figure prominently. (Courtesy of Scottie Franklin.)

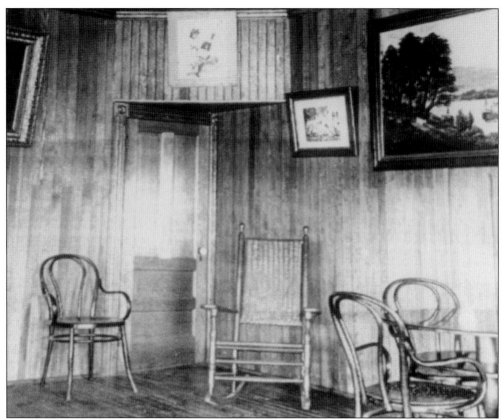

The Riverside had a lobby and a bar with small rooms for rent upstairs. Spittoons were provided for the guests at the time in the lobby area. (Courtesy of Scottie Franklin.)

# *Four*

# CHURCHES, SCHOOLS, AND THE LIBRARY

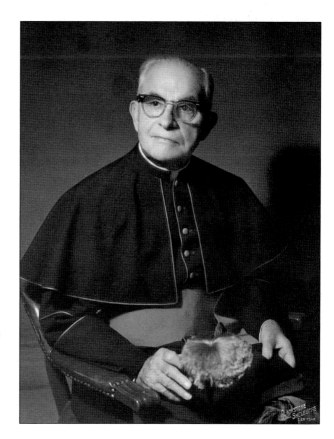

Rev. Msgr. Joseph A. Mulligan was the pastor of the Church of St. Elizabeth for 32 years. He was a native of Clinton and was ordained June 2, 1917 in St. Patrick's Cathedral in New York. When he died in 1972 at the age of 83, he had been a priest for 55 years. The church has dedicated a community room in his memory. (Courtesy of Eleanore Przygucki.)

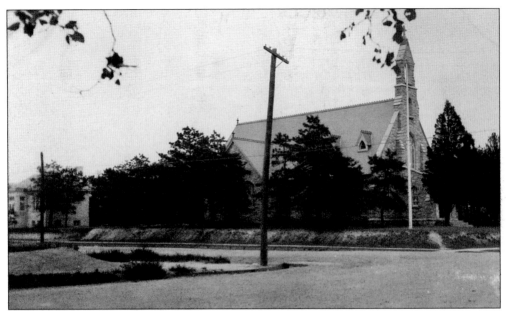

Before the Church of St. Elizabeth became an official church on September 18, 1907, the Catholics of Avon attended services at St. Rose Church in Belmar. As the Catholic population rose, it was decided that a new church would be built. The cost was not to exceed $19,000. The Church of St. Elizabeth was opened in 1908, and this postcard dates to c 1921. (Courtesy of Mr. and Mrs. Knubbert.)

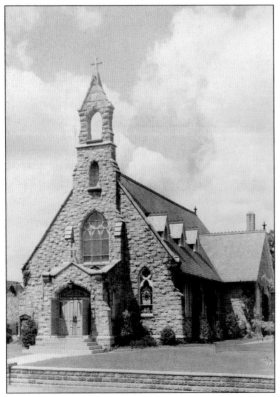

The church in this c. early 1900s photograph became the Church of St. Elizabeth for 500 Catholic families. The architect was J. O'Rourke & Sons of Newark. Note the windows on the slate roof. During the warm weather, the windows would be opened with the pulling of ropes. The doors were made of wood. If you look closely, you will note that the bell had not yet been installed and the statue of St. Elizabeth of Hungary had not yet been placed. The church was named after St. Elizabeth and is located on Lincoln and Fifth Avenues. (Courtesy of the Church of St. Elizabeth.)

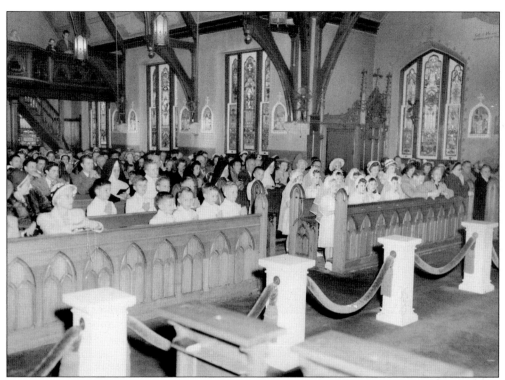

First Communion Day on May 21, 1950, shows a host of young boys and girls dressed in white. The nuns seated were the Sisters of St. Joseph from Chestnut Hill . They were the religious instructors for the children of the parish at the time. Jack Nicholson, the actor, received his First Communion in this church in the 1940s. (Courtesy of the Church of St. Elizabeth.)

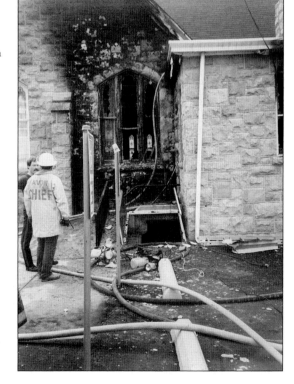

On Friday, August 22, 1986, the sacristy of St. Elizabeth was extensively damaged by fire. The August 23, 1986 *Asbury Park Press* reported that the "northeast corner of the church, which houses the sacristy, where vestments and religious items are stored, sustained the most damage." (Courtesy of the Church of St. Elizabeth.)

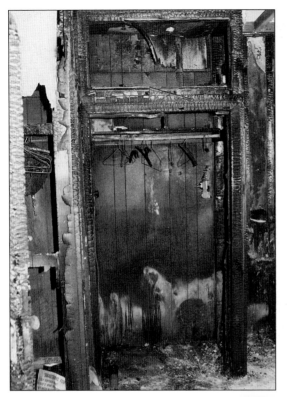

Chief Joseph Hagerman of the Avon Police Department and the Avon Fire Department worked hard with his crew to diminish the extensive smoke damage. The Neptune Fire Department also joined the town's firefighters in their effort to control the fire and smoke. The sacristy was later gutted and although there was smoke damage throughout the building, the water damage was limited to the area where the fire had started. (Courtesy of Church of St. Elizabeth.)

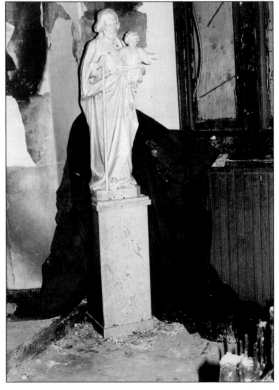

After the fire was under control, it was decided that Mass be held in the borough hall auditorium. The organ and its pipes had been completely demolished. The fire also burned the paint off the interior walls of the church. (Courtesy of the Church of St. Elizabeth.)

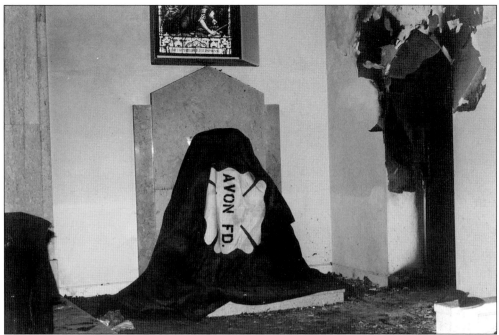

As everyone departed from the premises, a fireman from the Avon Fire Department had placed his jacket over the tabernacle. This touching photograph symbolizes how precious the tabernacle of the Holy Eucharist is to the community at large. (Courtesy of the Church of St. Elizabeth.)

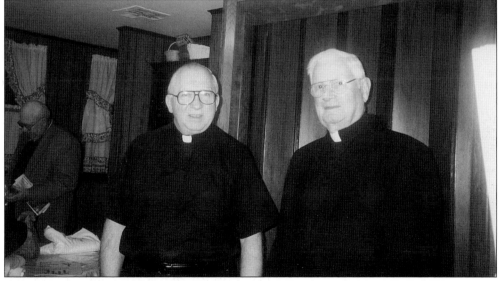

From the ashes of the horrendous fire of August 22, 1986, Pastor "Joe" Radomski, left, not only rebuilt and restored the original church but added a new section, accommodating parishioners with more seating space. Restrooms and a meeting room were built below the addition. Msgr. John J. Endebrock, right, and the pastor gave much comfort to their parishioners in their hour of need. Father Joe sincerely felt that the fire had brought the community closer together.

Fortunately, the church survived the tragedy. The bells still toll, and a statue of St. Elizabeth remains in its special place of honor. The windows on the roof were removed in the 1970s. To the right of the church is the rectory.

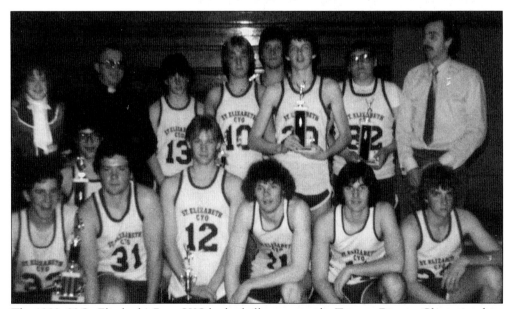

The 1982–83 St. Elizabeth's Boys CYO basketball team won the Trenton Diocese Championship. John Sweeney and his sister coached them to their victory. (Courtesy of the Church of St. Elizabeth.)

In 1916, the Methodist church was constructed in Avon at 507 Garfield Avenue. The Methodists of Avon had finally found a permanent home. For 15 years, they had gone from home to home to practice their faith. Now they could worship as a community in their own church. This photograph was taken c. 1926. (Courtesy of the Avon Public Library.)

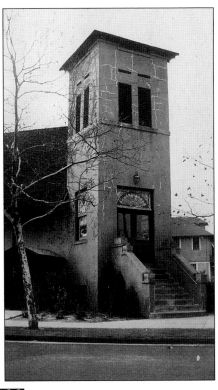

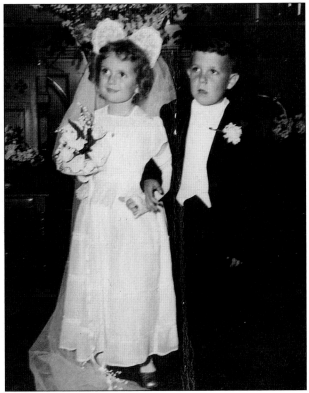

Every year, the Avon Methodist Church held a "Tom Thumb" wedding ceremony. In the 1940s, the young couple was Elaine McIntyre Weeden and Daniel Lee. The groom, looking very handsome, appears apprehensive. The beautiful bride, however, appears happy as she smiles at the photographer. (Courtesy of Daniel Lee.)

After the Methodist church was erected, the congregation attendance began to rise. Today, the building still maintains its original style. The entrance appears to have changed slightly, and an air conditioner can be seen at the right as a sign of the times.

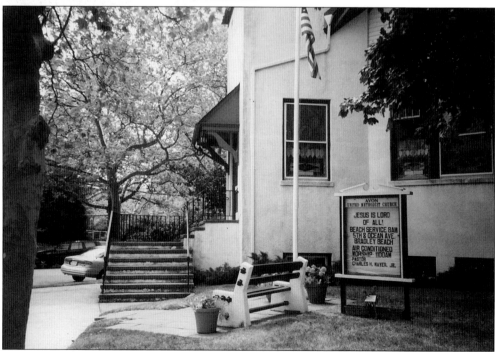

An inviting atmosphere is present in this view of the Methodist church. Note the bench and the flower pots on either side of it. The sign shows the event of the day and does not fail to denote that the church is air-conditioned.

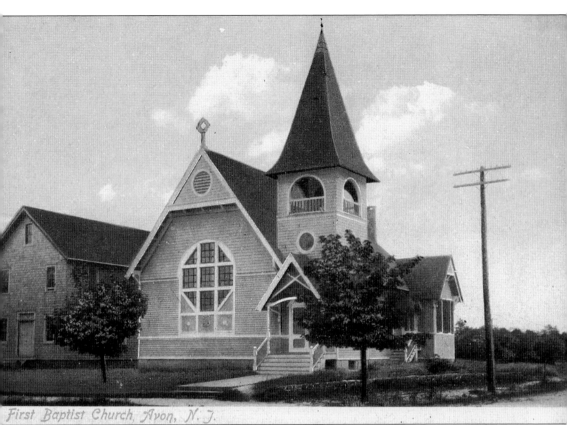

First Baptist Church, Avon, N. J.

As told by Rev. Thomas Taylor at the dedication and mortgage-burning ceremony on November 18, 1896, "I happened to be passing Mr. Batchelor's place of business one day. I went in and asked him whether he would donate a [building] lot for a church in Avon (then Key East). Mr. Batchelor was not at first inclined to grant the request, but before I left, I secured a paper on which was written an agreement to donate a lot 100 by 150 feet in size." In October 1886, the First Baptist Church of Key East was incorporated. The Reverend Thomas Taylor was the first pastor. The first church had 30 members. After the church was established, Reverend Taylor resigned as pastor, and a new pastor was appointed. This postcard dates to c 1890. (Courtesy of Michael, Avon Pharmacy.)

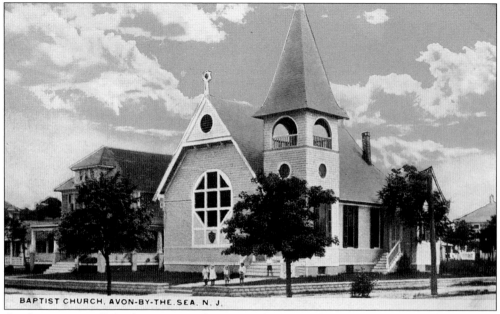

BAPTIST CHURCH, AVON-BY-THE-SEA, N. J.

On the morning of March 11, 1887, a lamp caused a fire in the partially constructed church. It was rumored that arson was the cause. However, the members were determined to have their own church. A new building committee was formed and the church was reconstructed. The cost of the building was $4,250. Upon completion of the church, it was named the First Baptist Church of Avon-by-the-Sea. In October 1927, under Rev. Alexander G. Graham Jr., the name of the church was changed to Taylor Memorial Baptist Church in honor of the pastor who walked three miles every day to hold services at the church. (Courtesy of Tina Ventimilia.)

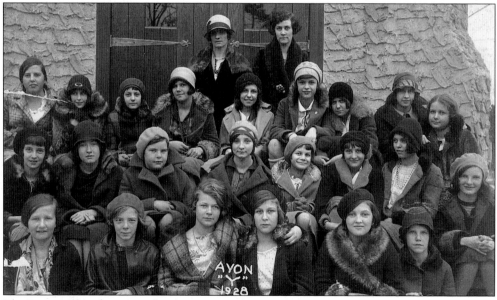

The Baptist Church was involved in many activities. In this photograph, Avon youths of 1928 sit on the steps of the church. Note the fashion of the day. The two women behind the group appear to be facilitators. Perhaps they were embarking on a field trip. (Courtesy of the Avon Public Library.)

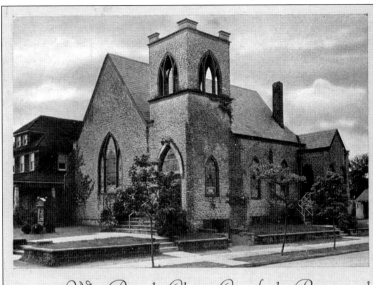

**Taylor Memorial Baptist Church**

Fifth and Sylvania Avenues
Avon-by-the-Sea, N. J.

Carlton R. Whitehead
PASTOR

LORD'S DAY SERVICES
Bible School 9.45 A.M.
Morning Worship
11.00 A. M.
Evening Worship
7.45 P. M.

*We Preach Christ Crucified, Risen and Coming*

The Taylor Memorial Baptist Church has its own "time capsule." The cornerstone was donated by the Neptune Stone Company. The box in the cornerstone contained some of the following items: the *Seaside Keynote*, Key East, July 15, 1885; the *Asbury Park Journal* and the *Monmouth Republican*, January 28, 1888; the *Shore Press*, December 30, 1887; the *Examiner* and the *Chronicle*, New York, 1886 and 1888; and the *Baptist Weekly*, New York, April 1886. A slip of paper contained the information that "the first Baptist Church of Neptune City was organized on Feb 13, 1881 with 56 members." Also included were the minutes of organization meetings held on August 6, 1883, in the Key East Public School House. At 2p.m. on April 29, 1886, the cornerstone was laid by Edward Batchelor. (Courtesy of Tina Ventimilia.)

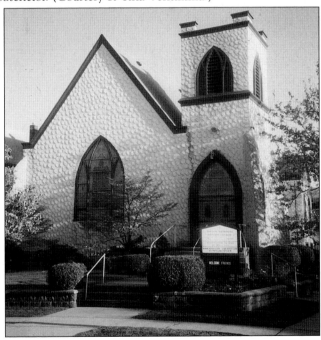

In later years, the exterior of the Taylor Memorial Baptist Church was refinished, the bell tower was redesigned, and a new pipe organ was installed and new stained glass windows were added. The church still stands at its original site, the corner of Fifth and Sylvania Avenues. It had retained its original style for 40 years before modernization.

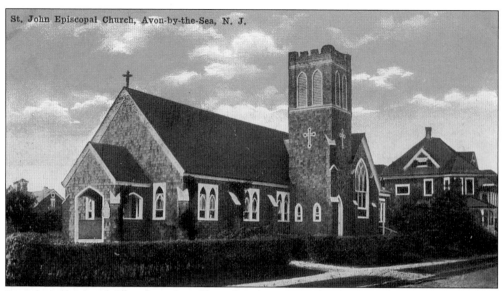

St. John Episcopal Church, Avon-by-the-Sea, N. J.

St. John's Episcopal Church is the oldest church in Avon-by-the-Sea, shown in this *c.* late-1800s postcard. In the late 1800s, Rev. and Mrs. Robert F. Innes founded the Home of the Merciful Savior for Crippled Children (the building that was later attached to the Avon Inn) as a summer home for disabled children. In 1883, tent services were conducted on the site of the church, which was located on the corner of Woodland and First Avenues. In 1884, a small wood frame building was erected and used for church services. (Courtesy of Mr. and Mrs. Knubbert.)

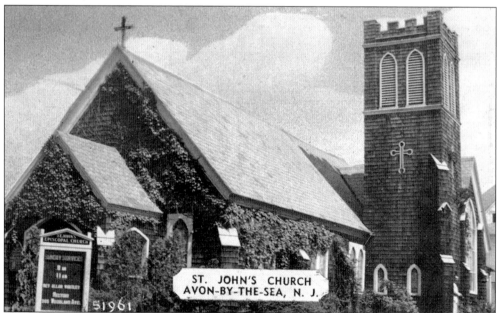

ST. JOHN'S CHURCH
AVON-BY-THE-SEA, N. J.

With the prosperity of the Jersey shore in the 1900s, a need for a larger church arose. In 1911, a proposal for enlargement of St. John's Church was executed. On July 4, 1913, the incorporation of St. John's Church was conceived. A rectory was purchased at 305 Woodland Avenue. Because of the efforts of the St. John's Guild (a women's group) the money needed for the purchase and subsequent improvements were obtained. (Courtesy of Jane Gannon.)

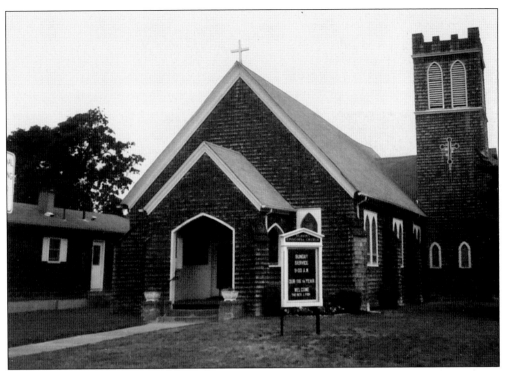

During WWII and in the following years, vacation patterns changed. People no longer spent entire summers in Avon. Their inclination was to spend only a few weeks. In 1977, attendance dropped so low that costs had to be reduced. The rectory was sold. Today, the church still stands on the original site. The leaders of the church still maintain the property, and services are held during the summer months.

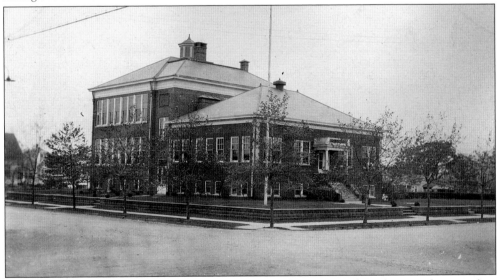

The Avon Public School opened its doors on April 1, 1909. This photograph was taken in 1921. At one time, the public library was located in the school, while in search for a permanent location. The school is located on Lincoln and Fifth Avenues. (Courtesy of Mr. and Mrs. Knubbert.)

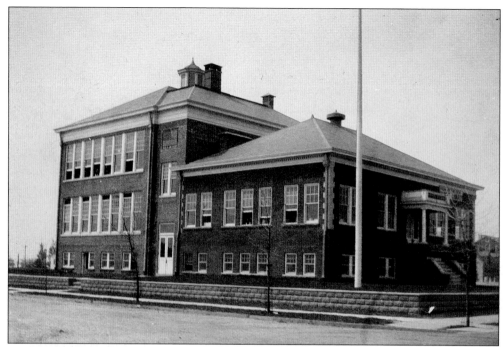

A June 19, 1925 article in the *Avon Journal* featured a story about Avon Public School's graduating class of 1925. Twenty-seven graduates received diplomas. The article states that the class motto was "labor conquers all things." The principal and class teacher Grace Crook—with the help of Alice Crook and former graduates—presented an outstanding and entertaining program. All graduates planned to attend high school. (Courtesy of the Avon Public Library.)

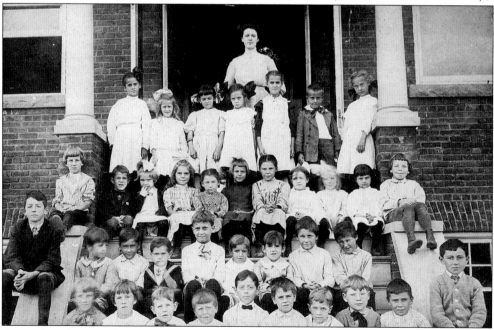

A proud teacher stands with a group of "enthusiastic students," c. 1900s. The 37 children in the photograph range considerably in age. (Courtesy of the Avon Public Library.)

These students are the eighth-graders of 1914. The girls are nearly as tall as the two boys standing behind them. (Courtesy of the Avon Public Library.)

This is the graduating class of 1917. The photograph appears to have been taken on the school lawn. It is difficult to spot the teacher, since they all look like students. (Courtesy of the Avon Public Library.)

This is Avon Public School's sixth grade class of 1924. Their teacher was Esther Roake. The students are, from left to right, the following: (top row) Bill McKinley, Erwin Mertens, one unidentified student, Sidney LaVance, Harry Longstreet, one unidentified student, Rena Cole, and Harry Cuttrell; (second row) two unidentified students, Francis Goodrich, Myra Stanton, George Hampton, one unidentified student, John Ogle, Samuel Hampton; and Mulford Hagerman; (third row) two unidentified students, Josephine Grissman, Frank Applegate, Arthur Rhodes, one unidentified student, Lester Sperry, and two unidentified students; (bottom row) Betty Case, Florence Lee, two unidentified students, Voorhes Clayton, Joe Jocaloni, Dorothy Bohcock, and one unidentified student.

At right is Barbara Ligo's report card from the 1940s. The quote on top of the card is still applicable today. "The Home and School Should Work Together for the Good of the Child." (Courtesy of Barbara Ligo.)

Below are grades from Barbara Ligo's report card. Notice the many areas that were graded—especially under the citizenship ratings section. Report cards of the 1940s and before appear to have been strict. One had to excel not only in the general subject areas, but had to pass the sub-areas as well. The marking key was as follows: A was Superior, 95–100; B was Very Good, 90–94; C was Average, 80–89; D was Below Normal, 70–79; F was Failure; and I was Improving but still failing. Certainly, Barbara was an excellent student. (Courtesy of Barbara Ligo.)

*The Home and School Should Work Together for the Good of the Child*

# Avon Public School
### Avon-by-the-Sea, N. J.
### 19_44_ · 19_45_
### Report to Parent of Pupil's Work
Grades 4, 5, 6, 7, 8

Name *Barbara Ligo*

Teacher *L Watres*

Grade ___4___

## MESSAGE TO PARENTS

This card is a direct message from your child's teacher. It is intended to give you information concerning his work in school.

The work of our school is related to everyday life. It endeavors to help the children do better those desirable things they will need to do. By close and friendly cooperation between school and home, we hope to develop in the character of the child:

THE POWER TO THINK
THE POWER TO FEEL
THE POWER TO KNOW
THE POWER TO DO

Parents are most cordially invited to visit the school at any time. Teachers will be pleased to confer with parents relative to a child's work when not on classroom duty.

*Barbara Ligo*

| Subject Matter Ratings | 1 | | 4 | | 6 | Av. |
|---|---|---|---|---|---|---|
| Reading | | | | | | |
| Understands what is read | A | A | A | A | B A | A |
| Aquaints himself with new words | A | A | B | A | A A | A |
| Oral Reading | A | A | A | A | A A | A |
| Spelling | | | | | | |
| Masters weekly words | A | A | A | A | A A | A |
| Applies spelling to other subjects | B | A | A | A | A A | A |
| Handwriting | B | B | C | B | B B | B |
| Written Language | | | | | | |
| Composition | C | B | A | A | B B | B |
| Uses words correctly | C | B | B | A | A A | B |
| Grammar | D | B | B | B | B B | D |
| Geography } | A | A | A | A | A B | A |
| History and Civics } | | | | | | |
| Arithmetic | | | | | | |
| Is careful in fundamentals | A | A | B | A | A A | A |
| Knows facts necessary for grade | A | B | A | A | A A | A |
| Can apply knowledge to new work | A | B | A | A | B B | B+ |
| Able to solve problems well | A | B | B | A | B B | B |
| Art | B | B | B | B | B B | B |
| Music | C | B | B | A | A A | B+ |
| Science | D | B | B | B | A B | B |
| Hygiene | B | B | B | B | B B | B |
| Physical Education | B | B | B | B | A A | B |

| Citizenship Ratings | 1 | 2 | 3 | 4 | 5 | 6 |
|---|---|---|---|---|---|---|
| Social Habits | | | | | | |
| Refrains from unnecessary talking in class | G | G | G | G | G | G |
| Listens politely when someone is talking | G | G | G | G | G | G |
| Works and plays well with others | E | E | E | E | E | E |
| Is good leader in activities | E | E | E | E | E | E |
| Work and Study Habits | | | | | | |
| Is attentive to directions | G | E | E | E | E | E |
| Makes good use of time | G | E | E | E | E | E |
| Starts and finishes work promptly | G | G | G | G | G | G |
| Prepares work neatly | E | E | E | E | E | E |
| Makes honest effort in work | E | G | G | G | G | G |
| Personal Habits | | | | | | |
| Obeys promptly and willingly | E | E | G | G | G | G |
| Exercises good health habits in school | E | E | E | E | E | E |

Comments

Marking Key for Citizenship Ratings:

E  Excellent
G  Good
F  Fair
U  Unsatisfactory

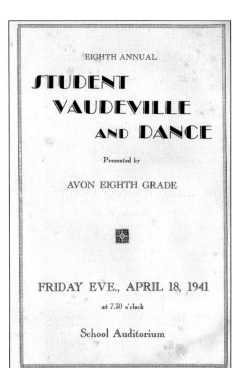

EIGHTH ANNUAL

# STUDENT VAUDEVILLE AND DANCE

Presented by

AVON EIGHTH GRADE

FRIDAY EVE., APRIL 18, 1941

at 7.30 o'clock

School Auditorium

On Friday evening, April 18, 1941, the Avon Public School's eighth grade presented the Student Vaudeville and Dance. The event was a yearly one, and this program was the annual eighth grade performance. The song "Playmates" was performed by the beginners and first grade. All grades participated, and the event was well attended. (Courtesy of Dorothy Gallagher.)

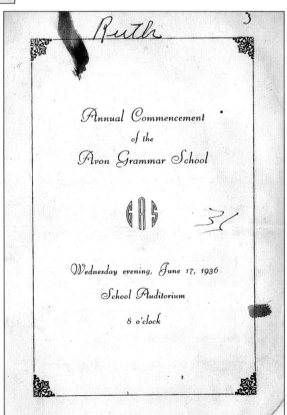

Ruth

Annual Commencement
of the
Avon Grammar School

AGS

Wednesday evening, June 17, 1936
School Auditorium
8 o'clock

This is a commencement program for the eighth grade graduation, held on June 27, 1936.

## Program

* * *

INVOCATION.............................Rev. C. Whitehead

HYMN...........................................Eighth Grade

SALUTATORY WELCOME...............William Butler

CLASS HISTORY.............................Jean Child

SELECTION — "Lullaby"........................Chorus

CLASS WILL.........................Madeline Busch

SELECTION — "Fairest Chiquita.............Chorus

CLASS PROPHECY...........................Martha Lee

SELECTION — "Italian Folk Song"................Chorus

CLASS GIFTS................................Doris Salmons

The programs were well done and included a variety of beautiful happenings. There were speeches, music, an invocation, and a benediction. Much work went into making the program special for the parents, friends, and relatives of the graduating class. (Courtesy of Dorothy Gallager.)

## Program

* * *

**TOWN MEETING OF THE AIR**

TOWN CRIER.....................Michael Guarino

CHAIRMAN.........................William Butler

SPEAKER "Traditional Education"..Madeline Turner

SPEAKER "New Education"................James Holmes

QUESTIONS BY MEMBERS OF SEVENTH GRADE

* * *

SELECTION—"Song of Mexico"........................Chorus

VALEDICTORY FAREWELL...........Madeline Turner

CLASS SONG...................................Eighth Grade

PRESENTATION OF DIPLOMAS
                        Mr. James Babcock

BENEDICTION.........................Rev. George Whitehead

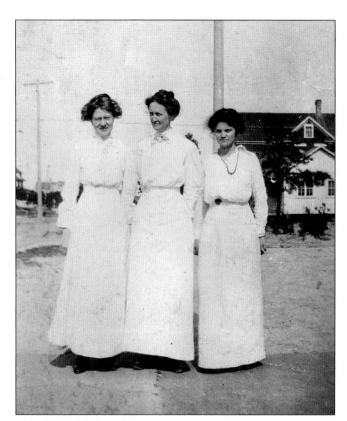

Three teachers dressed in white pose for this 1913 picture. They appear to be standing on an unpaved road. (Courtesy of the Avon Public Library.)

Teachers strike a pose in front of the school for this 1913 photograph. Students and an unidentified young man are standing in the background. (Courtesy of the Avon public Library.)

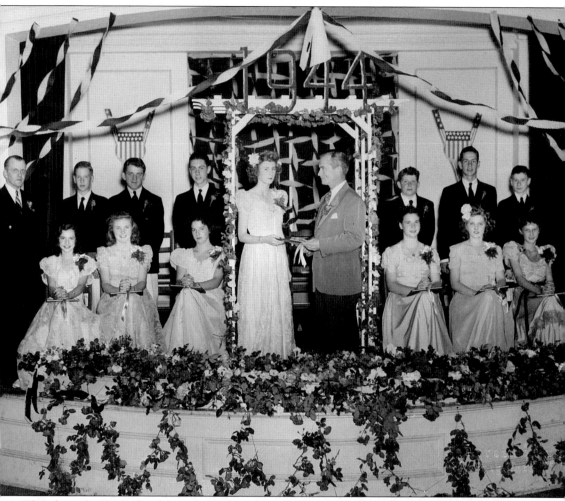

The class of 1944 looks elegant in graduation garb. The graduates are, from left to right, the following: (front row) Marianne Ligo Stauch, Delores Harris, Nancy Heffelfinger, Adelaide Loan Gibson, receiving her diploma from Henry Brewster, the president of the board of education; Dona Turner, Arlene ?, and Beverly ?; (back row) Ronald Wildrick, principal Steve Morris, Harry Cuttrell, Bruce Jobes, Bill ?, Bill Salmons, and one unidentified student. (Courtesy of the Avon Public Library.)

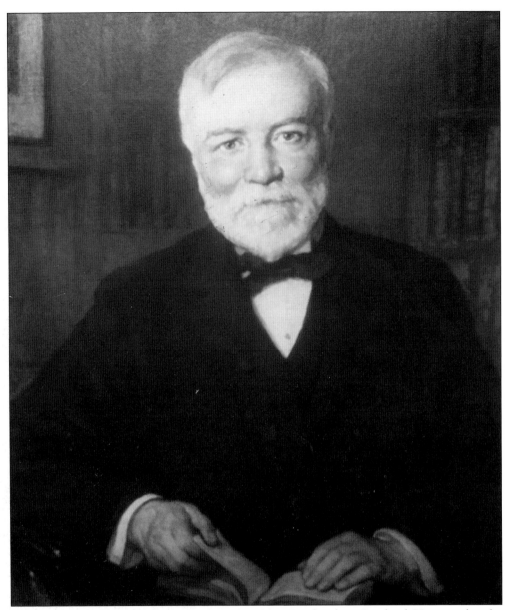

Andrew Carnegie was born on November 25, 1835 in Dunfermline, Scotland. He arrived in the United States aboard the *Wiscasset* from Glasgow on August 14, 1848. He settled in Pittsburgh and became one of the original steel magnates of the 1800s. He was a generous philanthropist contributing to many causes. In 1916, the Public Library of Avon was erected. Andrew Carnegie's foundation had granted $5,000, and the dream of a town library became a reality. Land for the building was donated by friends of Avon. One of Carnegie's business maxims was, "Put all your eggs in one basket and then watch that basket." Andrew Carnegie died on August 11, 1919, and is buried in Sleepy Hollow Cemetery in North Tarrytown (now Sleepy Hollow), New York. (Courtesy of the Avon Public Library.)

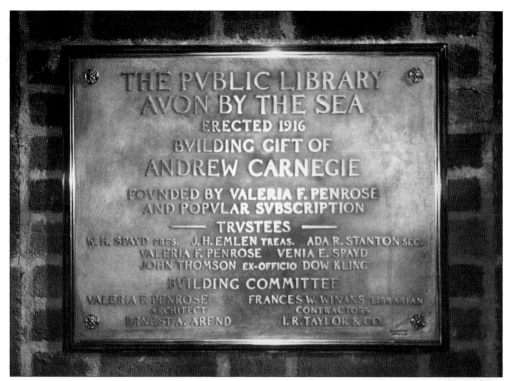

This plaque was installed on a wall of the library to pay tribute to Valerie F. Penrose, the founder of the library, and to Andrew Carnegie. (Courtesy of the Avon Public Library.)

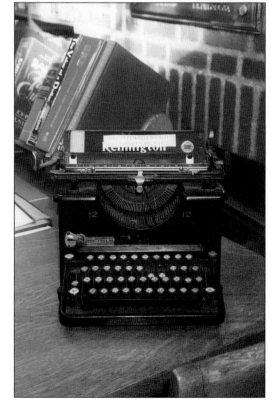

This typewriter became a part of the library in 1930 to ease the workload of the librarian, who would write the catalog cards in script. The typewriter will always remain a part of the library, but there is little doubt that it will ever be as essential as it was in the 1930s. (Courtesy of the Avon Public Library.)

Before the library building was erected at Garfield and Fifth Avenues, two young women decided to establish a library in Avon. Valerie Penrose of Philadelphia and Frances Winans of Allenhurst spent their summers in Avon. They decided to collect books from friends and start a library. The social hall of the Baptist church became the site of the first library. Daniel Applegate was the first librarian. From the Baptist church, the library moved to several sites: the Old Homestead on Washington Avenue, then the Avon School, and then a store. Finally, with the Carnegie grant and the donated land, the library moved to its present site. (Courtesy of the Avon Public Library.)

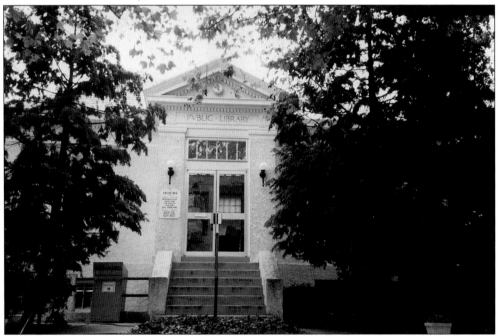

As the library continues to move toward the future, technology becomes an integral part of library services. Sheila McCarthy Watson, the library director and town historian, has kept the library's historical qualities. While still serving the public's traditional reading needs, computerized library services and public access to the Internet have been added. (Courtesy of the Avon Public Library.)

*Five*

# THE WATERS
# EMBRACING AVON

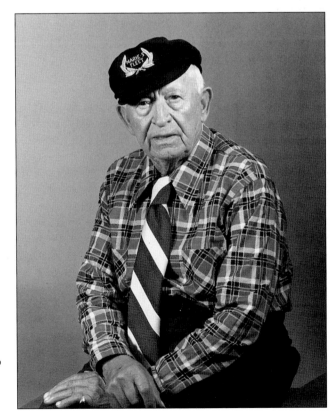

Charles "Pop" Siegler was born in Poland and settled in Avon in 1945 after purchasing the fishing marina known as Avon Boat Basin. At one time, there were five party boats docked at the marina. In 1965, Siegler sold the property and moved to the Belmar Marina to spend time with his "sea faring buddies." (Courtesy of Denice and Hank Koch.)

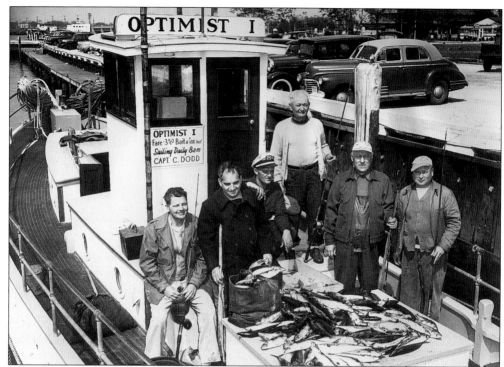

Charles Dodd, pictured here in a captain's hat in 1940, owned the *Optimist I*. He charged $3 for a fishing excursion. Today, the price is over $30. Dodd began his sea legacy as a young boy working for Walt Klings boathouse, which serviced about 150 rowboats. He later purchased Dodd's Marine Basin in Neptune. (Courtesy of Raymond Dodd.)

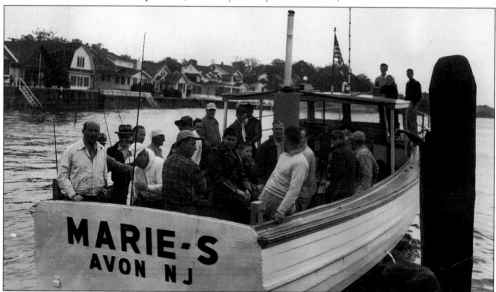

This party fishing boat was the original *Marie S*, owned by Charles Siegler. The boats would go out twice a day; morning runs would last from 8 a.m. to 12 p.m., and afternoon runs were from 2:30 p.m. to 6:30 p.m. Locals and vacationers would vie for the best spots on the rails for fishing. This photograph dates to *c*. 1945. (Courtesy of Denice and Hank Koch.)

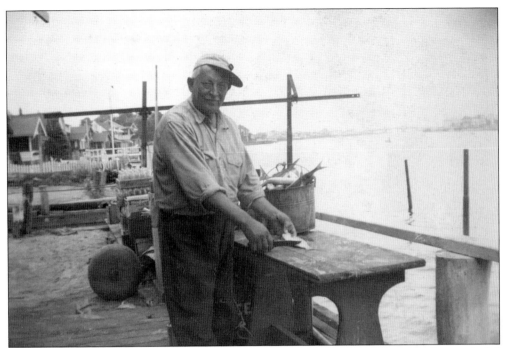

"Pop" Siegler gets ready for a day of fishing in 1950 at the Avon Boat Basin. The bait included squid, killies, and herring. Shark River bungalows can be seen in the background. (Courtesy of Denice and Hank Koch.)

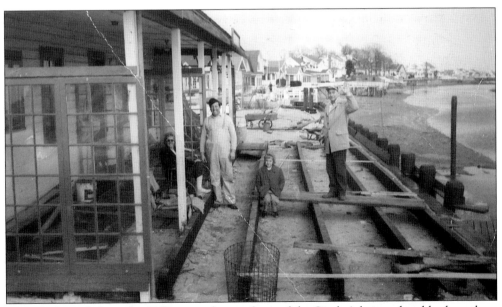

This photograph from the 1950s was taken in front of the Siegler's bait and tackle shop along the Shark River. The shop supplied all fishing needs and had a diner. Shown in the photograph are Walter Siegler (son of Charles), an unidentified worker, and Denise Siegler (the daughter of Alice and Walter Siegler) sitting on a plank. Denice's grandmother is seated on the bench. (Courtesy of Denice and Hank Koch.)

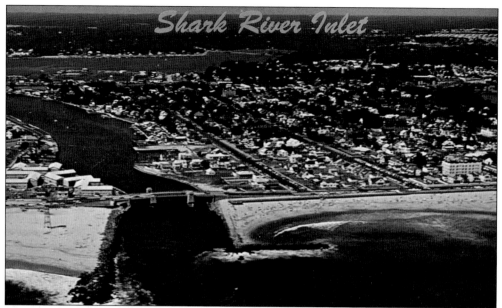

Before the 1800s, the Shark River was called *Nolletquesset* by the Native Americans. The colonists called it the Shark River. "The aboriginal appellation is mentioned in the deed dated July 25, 1689 from, Houghame, Wayweenotam, and Auspeakan to Nicholas Brown of Shrewsbury, for land westward of Pequodlenoyock Hill between the Pine Bridge and the Shark River." Today, the area formerly known as Key East and Ocean Beach is Avon-by-the-Sea and Belmar. (Quotation from the Shark River district genealogies; photograph courtesy of Michael, Avon Pharmacy.)

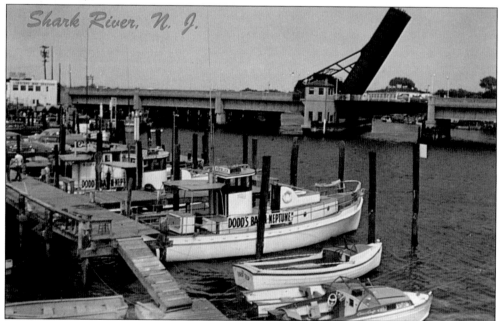

This 1950s postcard shows Dodd's Marina with the bridge opened for boat traffic in the background. Anchored at the dock are two of Charles Dodd's boats. (Courtesy of Raymond Dodd.)

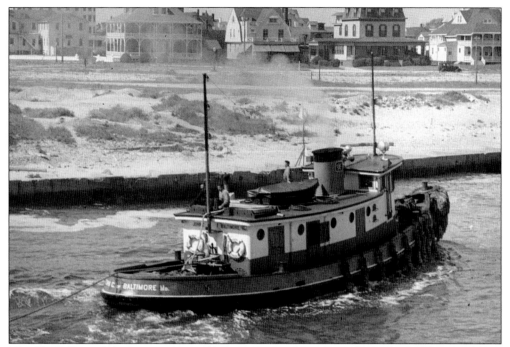

The Shark River Inlet was made steadfast in 1916 and has been dredged several times due to natural erosion. One year, the damage was caused by muskrats that had packed tons of mud that weakened the bulkhead, causing it eventually to give way. Charles Dodd worked on the 1949 federal dredging project that took mud from the inlet to the southern corner of Belmar Basin. The tugboat in the photograph above assisted in the project. (Courtesy of Raymond Dodd.)

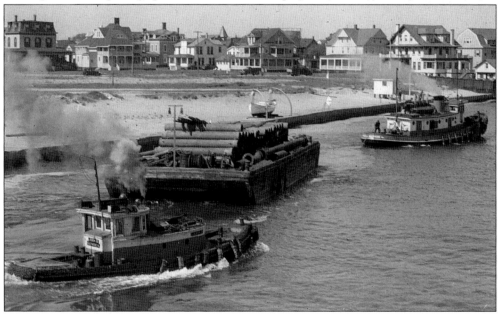

The barge in this 1949 photograph carried the pipes that were used in the dredging. The crew would pump the sand from the inlet onto the beach. This process lasted two months. (Courtesy of Raymond Dodd.)

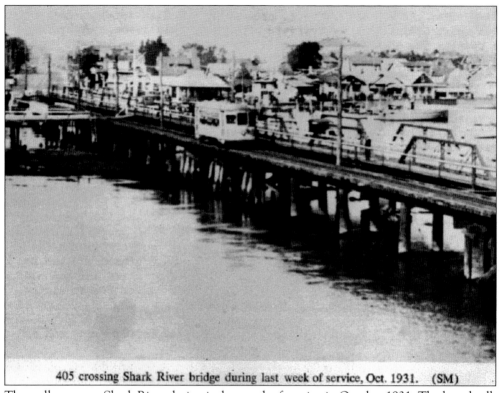

405 crossing Shark River bridge during last week of service, Oct. 1931. (SM)

The trolley crosses Shark River during its last week of service in October 1931. The boardwalk seen led to Riggs Boathouse. (Courtesy of Scottie Franklin.)

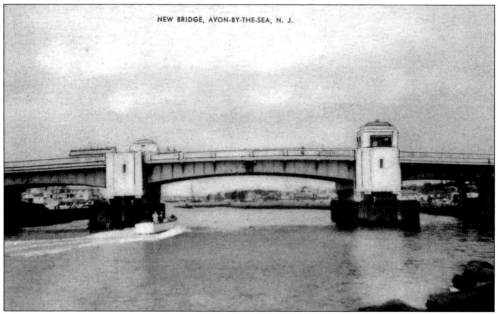

NEW BRIDGE, AVON-BY-THE-SEA, N. J.

The new bridge on Ocean Avenue was built in 1934. The bridge services the boats bound for the Atlantic Ocean through the Shark River. It connects the borough of Avon with Belmar. (*Asbury Park Press*, February 3, 1963.)

78

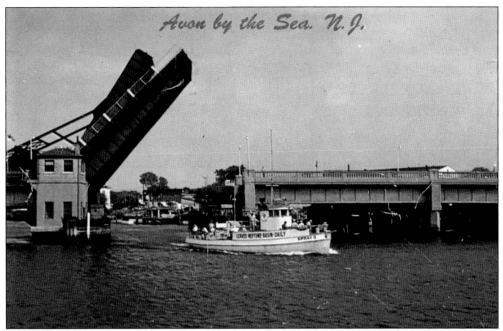

*Avon by the Sea. N.J.*

Almost every half-hour the bridges on Ocean Avenue and Main Street open for boat traffic during the spring, summer, and fall. The Main Street Bridge, pictured here in the 1960s, opened only at one end. It now opens in the middle. The *Spray II*, captained by Peter Saro is on its way to the ocean. (Courtesy of Jane Gannon.)

During the Revolutionary War, the Shark River Inlet played an important role providing salt for the army for preserving rations. The continental government established a number of saltworks along the New Jersey coast. One was located on the south bank of the Shark River Inlet (Ocean Avenue). The other was on the south bank of the Shark River, where the bridge enters Belmar (Main Street). Rebel saltworks were often the target of the British Army. (Taken from the Shark River District Genealogies.)

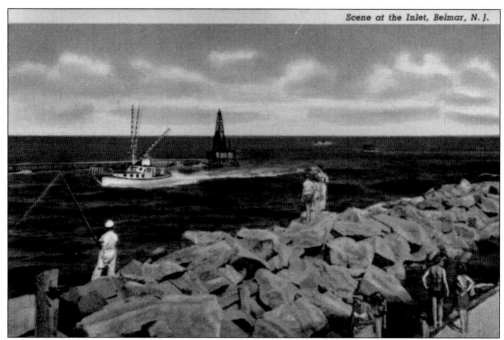

This 1950s postcard depicts a tuna boat coming into the inlet after a day of fishing. Fishing off the rocks and watching the boats come in are still favorite pastimes of the locals and visitors. (Courtesy of Michael, Avon Pharmacy.)

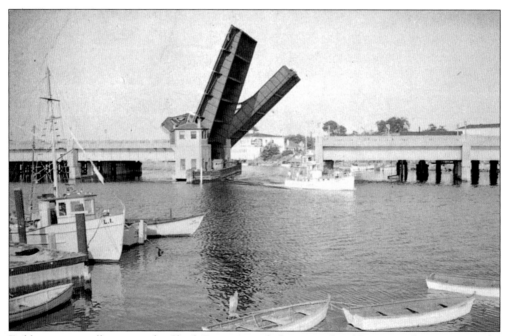

Fed by many small streams, the Shark River extends for two miles. (Courtesy of Jane Gannon.)

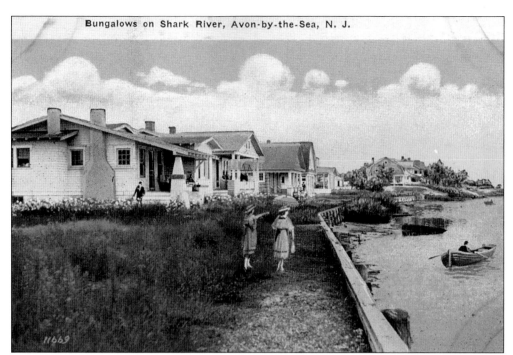

Bungalows on Shark River, Avon-by-the-Sea, N. J.

This postcard from the early 1900s shows the summer bungalows that lined the Shark River. Residents could take advantage of the breeze, boating, swimming, and fishing available to them right out the back door. (Courtesy of Mr. and Mrs. Charles Knubbert.)

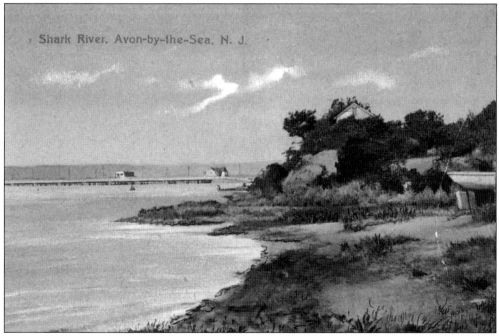

Shark River, Avon-by-the-Sea, N. J.

This is an artist's concept of Sylvan Lake in 1909 looking east. The ocean appears calm, and the postcard offers views of the lifesaving station and the boardwalk. (Courtesy of Michael, Avon Pharmacy.)

The occupants of the rowboat are keeping their eyes on Charlie, who is crabbing in the Shark River. His little sister sits behind him and his grandmother at the oars. The other woman in the boat is unidentified. (Courtesy of Daniel Lee.)

The Lee family is out on a rowing expedition on the Shark River in the 1920s. The young man on the front right is Charlie Lee. (Courtesy of the Lee family.)

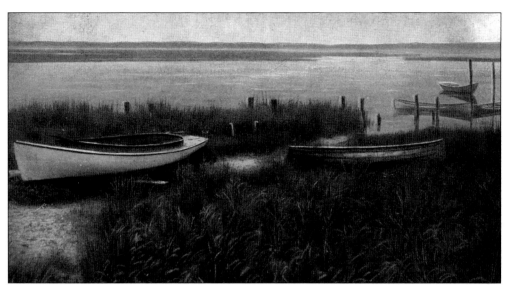

Shown is the Shark River as it looked around 1910. There was very little developed land east of Second Avenue and south of Garfield Avenue at the time. (Courtesy of Michael, Avon Pharmacy.)

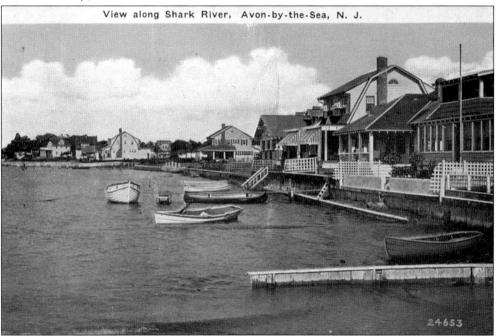

View along Shark River, Avon-by-the-Sea, N. J.

This photograph shows the Shark River, c. 1930. Many of the bungalows were rented for the summer by vacationers from Bayonne, Elizabeth, Newark (all in northern New Jersey), and New York. The first letters of these locations may explain the nickname of summer and weekend visitors, "bennies." Another theory behind the name derives from the $100 bills or "Benjamin Franklins" the weekenders would spend. Summer in Avon drew people from places throughout all of Hudson, Essex, and Bergen Counties, such as Jersey City, Harrison, and Rutherford. Many of these people purchased houses for summer vacationing, later choosing Avon as their main residence. (Courtesy of Michael, Avon Pharmacy.)

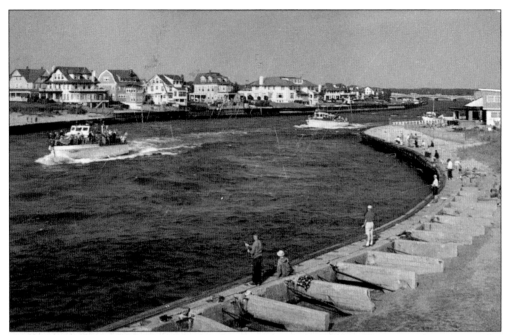

A panoramic view of the Shark River Inlet shows its daily parade of boats on their way to the ocean. Fishermen on the sea wall go for baby bluefish known as "snappers," porgies, bass, and weak fish. (Courtesy of Jane Gannon.)

This photograph taken in the 1960s shows Sylvan Lake between Second and Third Avenues. The gazebo was used all year long and in the winter served as a resting spot for ice skaters. (Courtesy of Beatrice Rommel.)

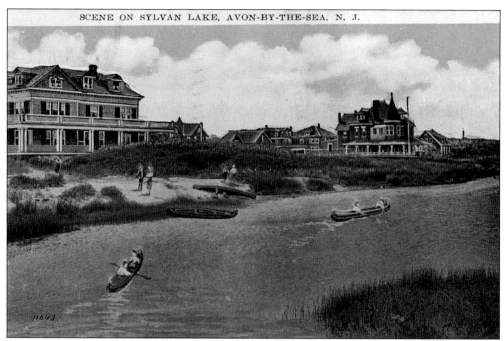

SCENE ON SYLVAN LAKE, AVON-BY-THE-SEA, N. J.

This postcard from 1933 depicts a busy Sylvan Lake, which is located between Avon and Bradley Beach. In the background on the left is the Whiff-O-Wind, a summer guest house. (Courtesy of Jane Gannon.)

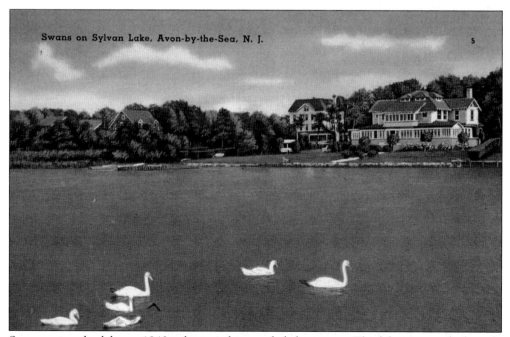

Swans enjoy the lake, c. 1940, when rowboats ruled the waters. The lake was stocked yearly with fresh fish. It is now complete with fountains and an island in the middle that provides a perfect nesting site for the resident bird population. (Courtesy of Vernon Fees.)

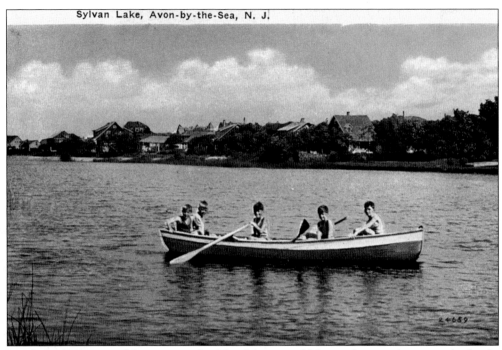

Local children enjoyed boating on the lake. Many would leave their rowboats on the banks unattended for the season. This postcard is dated 1929.

This is the view of the Atlantic Ocean as seen from the beach in Avon-by-the-Sea. The borough owes much to its proximity to the ocean. Its attraction brings over 50,000 summer visitors per year.

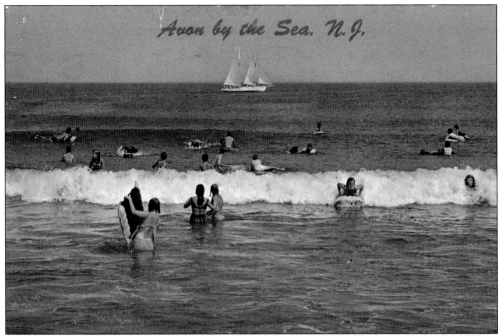

The ocean offers much to the daily and seasonal visitor. In this photograph from 1970, swimming, surfing, and sailing seem to be the activities of the day. The beaches are protected from 9 a.m. to 5 p.m. by lifeguards, and the area is cleaned nightly by the dedicated public works staff. (Courtesy of Michael, Avon Pharmacy.)

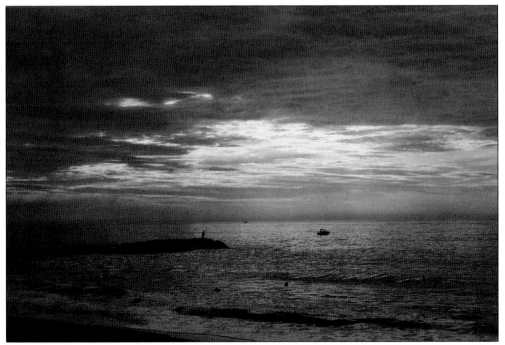

Sunrise on the ocean catches a lone fisherman on the jetty. Morning joggers and walkers alike take to the boardwalk soon after dawn.

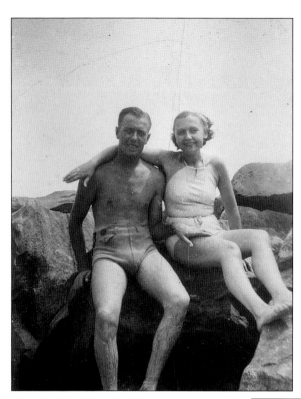

A happy couple, Charlie and Janet Lee, enjoy a day at the beach in 1932. (Courtesy of the Lee family.)

James Kirk (seated) and Milton Hampton are shown in 1935. At the time, Kirk was the youngest lifeguard in Avon. Kirk summered in Avon, and later settled here with his wife, Charlotte, and their two children until his death. Milton Hampton was a lifelong resident who worked for the road department. When he retired, his friends from Avon gave him a party and rewarded him with a bicycle. Attached to the poles in the background were ropes that would assist in rescues. Today, lifeguards use jet skis and floating buoys in their assists. (Courtesy of Charlotte Kirk.)

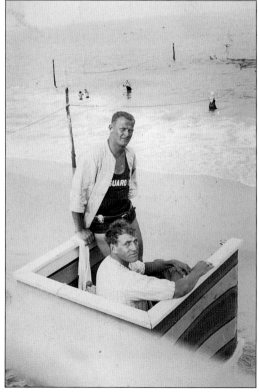

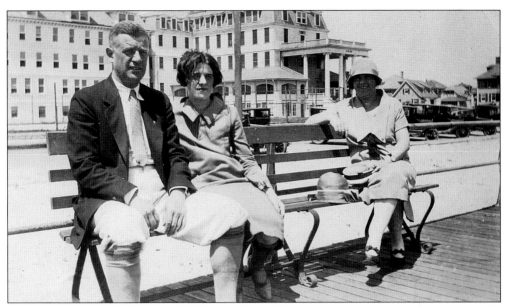

This photograph was taken on the boardwalk in 1927, with the Avon Inn in the background. To the left are Jim Toohey and Cecilia Kennedy. At the end of the bench is Aga Hayes. (Courtesy of Mary Buerck.)

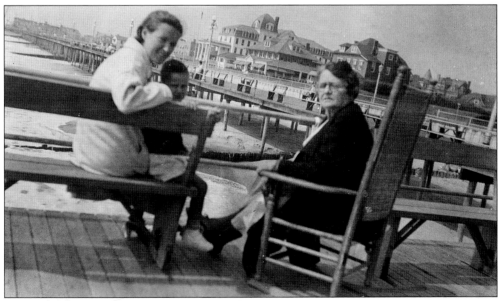

This photograph shows a view south from Woodland Avenue beach. On the left, Mary Buerck is sitting with Harry Buerck. Mrs. Mulligan sits on a rattan rocker. From the reversible bench, we can tell this photograph dates from the 1920s. (Courtesy of Mary Buerck.)

In this photograph from the early 1950s, a seven-year-old Jane Gannon is enjoying a snack on the beach. Her days on the beach may have inspired her extensive collection of Avon postcards. (Courtesy of the Clossey family.)

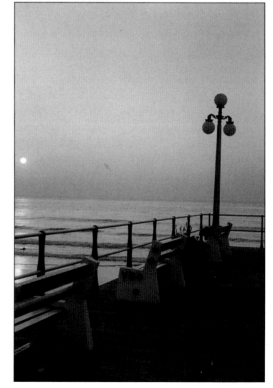

Mayor Jerry Hauselt took this signature photograph of the boardwalk. This view has been used for his "pride in Avon" lapel pins that he awards to citizens in the borough for random acts of kindness and civic pride. (Courtesy of Mayor Jerry Hauselt.)

## Six

# In Honor of Our Town Heroes

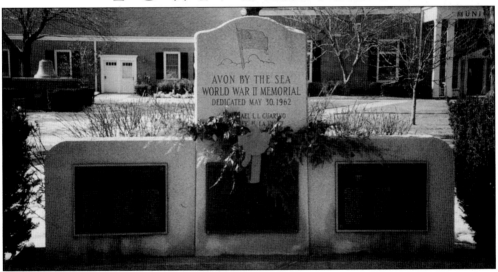

Heroes from Avon are honored throughout the borough. This memorial is a monument to those who died during WWII and was dedicated in 1962. The Municipal Building is in the background, and the monument for fallen firemen can be seen on the left.

The plaque pictured is located in St. Elizabeth Church and is dedicated to the memory of Captain Donald Stapleton, who died during WWII.

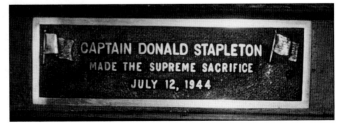

The WWI Monument stands in Thomson Square in front of the Municipal Building on Main Street. On Sunday, March 19, 2000, a memorial to those who perished in the Korean War, Vietnam Conflict, and the Gulf War was dedicated. The memorial stands in Thomson Square with the other memorials dedicated to the town's fallen heroes.

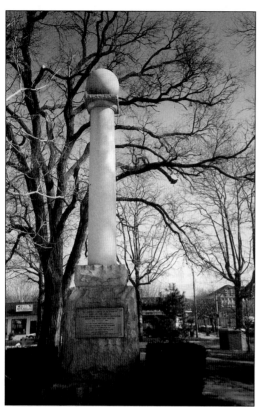

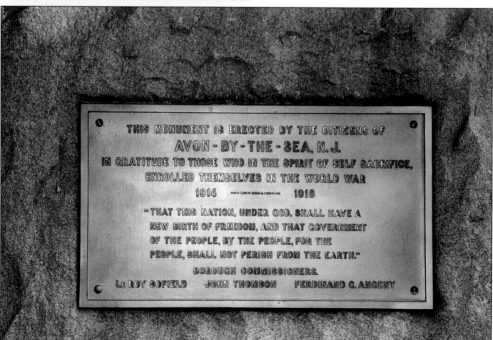

THIS MONUMENT IS ERECTED BY THE CITIZENS OF
AVON - BY - THE - SEA, N. J.
IN GRATITUDE TO THOSE WHO IN THE SPIRIT OF SELF SACRIFICE,
ENROLLED THEMSELVES IN THE WORLD WAR
1914  —  1918
"THAT THIS NATION, UNDER GOD, SHALL HAVE A
NEW BIRTH OF FREEDOM, AND THAT GOVERNMENT
OF THE PEOPLE, BY THE PEOPLE, FOR THE
PEOPLE, SHALL NOT PERISH FROM THE EARTH."
BOROUGH COMMISSIONERS.
LE ROY SOFIELD    JOHN THOMSON    FERDINAND C. ANGENY

The plaque at the base of the WWI Monument honors all who served in that war. It takes its words from Lincoln's *Gettysburg Address*.

UNITED STATES OF AMERICA
OFFICE OF PRICE ADMINISTRATION

N° 99885 BN

# WAR RATION BOOK No. 3

Void if altered

NOT VALID WITHOUT STAMP

Identification of person to whom issued: PRINT IN FULL

*Floyd B. Clayton*

(First name)     (Middle name)     (Last name)

Street number or rural route __410 Sylvania Av.__

City or post office __Avon__ State __N. J.__

| AGE | SEX | WEIGHT | HEIGHT | OCCUPATION |
|-----|-----|--------|--------|-----------|
| 33 | Male | 210 Lbs. | 6 Ft. In. | Army |

SIGNATURE *Floyd B. Clayton for Mrs. F. B. Clayton*
(Person to whom book is issued. If such person is unable to sign because of age or incapacity, another may sign in his behalf.)

**WARNING**

This book is the property of the United States Government. It is unlawful to sell it to any other person, or to use it or permit anyone else to use it, except to obtain rationed goods in accordance with regulations of the Office of Price Administration. Any person who finds a lost War Ration Book must return it to the War Price and Rationing Board which issued it. Persons who violate rationing regulations are subject to $10,000 fine or imprisonment, or both.

OPA Form No. R-130

**LOCAL BOARD ACTION**

Issued by _____
(Local board number)     (Date)

Street address _____

City _____ State _____

(Signature of issuing officer)

Shown is a WWII ration book from the Clayton family of Sylvania Avenue. During the war, these valuable books allowed families to get sugar, coffee, gas, and clothing, which were in demand due to the needs of the army. (Courtesy of the Clayton Family.)

Ration stamps like these from the Claytons' book were used throughout the war. Rationing was part of the war effort and ensured that items in demand were distributed fairly among families. Butter, meat, and automobiles were also in the rationing system. (Courtesy of the Clayton Family.)

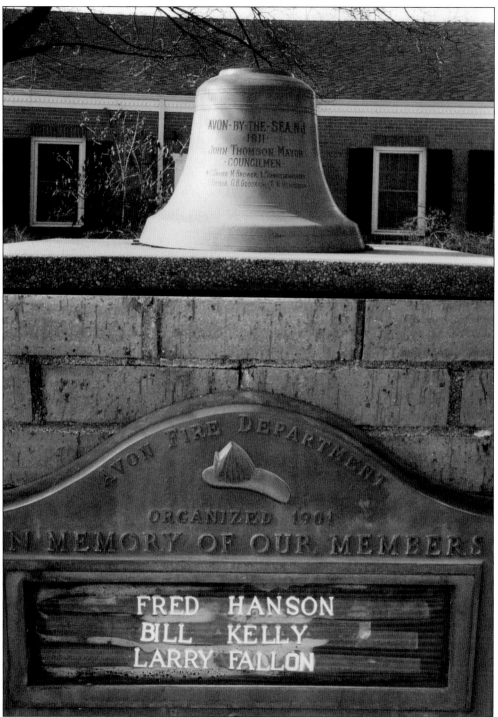

The Firefighter's Monument is marked by the bell from the old firehouse on Main Street and Stanton Place. The monument was organized in 1901 to honor deceased members of the department. It was dedicated in 1958. Each year, the monument honors recently deceased members of the department.

Avon Fire Company No. 1, First District, Neptune City, was organized after a fire at John Thomson's plant on Norwood near Fifth Avenue. The fire motivated taxpayers to petition Neptune City for better fire protection in 1899. In the spring of 1900, when the borough was incorporated, the Avon Fire Company was renamed "Active Fire Company." A dispute over membership in 1909 caused two factions of the department to split into the Avon Hose Company and the Avon Fire Company. It was not until 1957 that the two fire companies united, despite having been housed in the same building and fighting side by side during fires. At right is Chief Louis Schmatchment of the Active Fire Company in 1918. (Courtesy of the Avon Fire Department.)

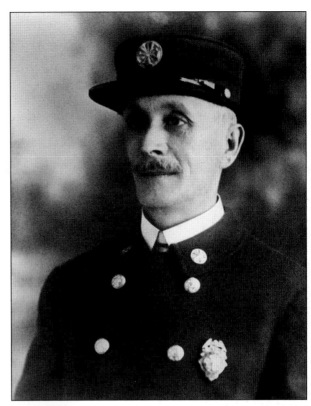

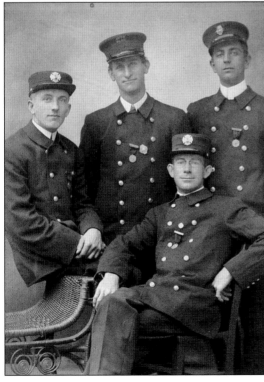

A photograph from 1918 of Avon's Active Fire Company includes Mr. Bing, Ike Gouldy, Lyall Salmons, and Dad ?. (Courtesy of the Avon Fire Department.)

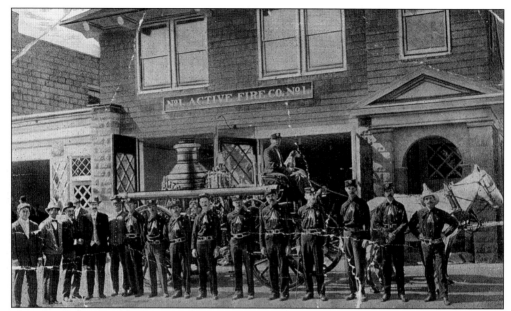

This 1901 photograph shows the Active Fire Company at its new home on Main Street and Stanton Place. This was the year the department received its first piece of fire fighting equipment, a 100-gallon chemical wagon, seen here drawn by the horse. In 2001, the fire department will celebrate its 100th anniversary. (Courtesy of Raymond Dodd.)

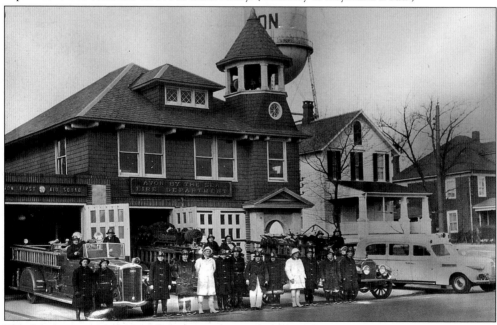

The fire department shows off its equipment in this 1940 photograph. Note that the First Aid Squad was housed in the same building at the time. Members of the fire department are, in the first row, from left to right, Charlie Lee, three unidentified members, Milton Hampton, the Assistant Chief, two unidentified members, Marvin Mytinger, one unidentified member, Charles Dodd, the chief, two unidentified members, and Bill Adcock. Those on the truck cannot be identified.

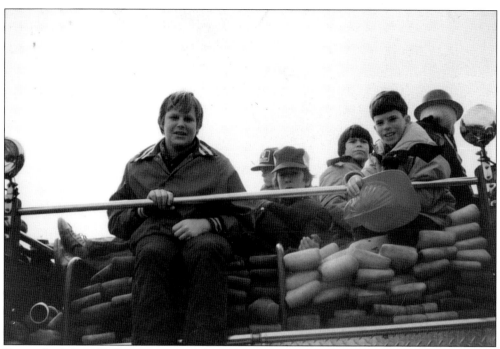

Future firefighter Kelly Hagerman, left, and friends ride on the fire truck as children in the 1980s during a parade. (Courtesy of the Hagerman Family.)

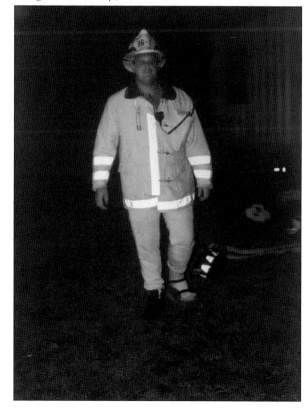

Firefighter Kelly Hagerman is dressed for duty in the 1990s. Avon has a dedicated roster of volunteers who are ready at a moment's notice. (Courtesy of the Avon Fire Department.)

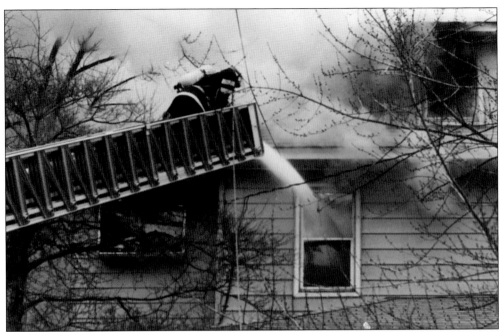

Firefighter Bob Booth hoses down a fire on West Sylvania Avenue. Today, the department has three fire trucks and 63 volunteer members. (Courtesy of the Avon Fire Department.)

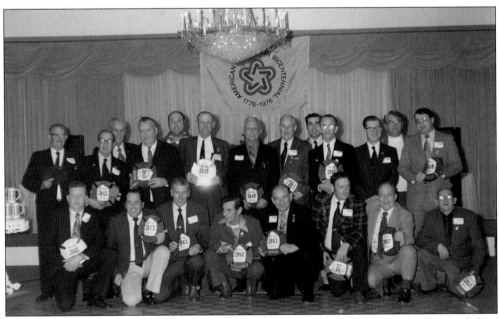

The Avon Fire Department celebrates its 75th anniversary in 1976. Pictured are, from left to right, the following: (first row) Lloyd Tasssey, Andy Saporito, Dave Gamble, Ed Colyard, John Newman, Jerry Hauselt, Bill Baer, and John Rhodes; (second row) Charles Dodd, Charlie Lee, Jack Murday, Milt Hampton, Carroll Clayton, John Ogle, Harry Andersen, Tom Gagen, and Dave Bushe; (back row) Niles Cole, Joe Hagerman, Bart Barry, and Jack Thompson. (Courtesy of the Avon Fire Department.)

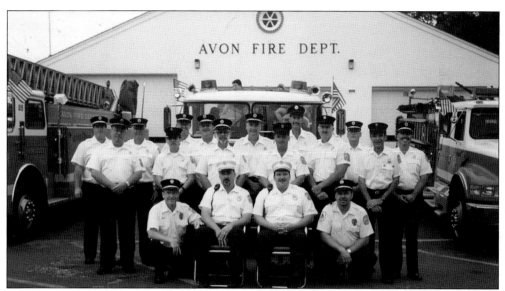

The Avon Fire Department in 1999 included, from left to right, the following members: (first row) Jim Outwater, Al Virgilio, Kevin Schmalz, and Ken Child; (second row) Tom Child, Pat Duffy, Bill Palmer, Scott Hauselt, Harry Cuttrell, and Gene Silva; (third row) Garth Greer, Karl Klug, Bill Adcock, Kelly Hagerman, John Toohey, Bob Booth, Don Greer, and Frank Gorman.

The Ladies Aid Society was organized as an auxiliary to the fire department in 1901, but was formerly chartered the Women's Auxiliary of the Avon Fire Department in the spring of 1949. The charter members were Betty Newman, Virginia Ogle, Betty Spies, Jean Weeden, and Virginia Colyard. Betty Newman is the only surviving charter member in Avon. The organization's purpose was to provide support and refreshment during fires. The organization also sponsors the yearly Easter Egg Hunt for the children in the community. (Courtesy of Mrs. Karl Gorman Klug.)

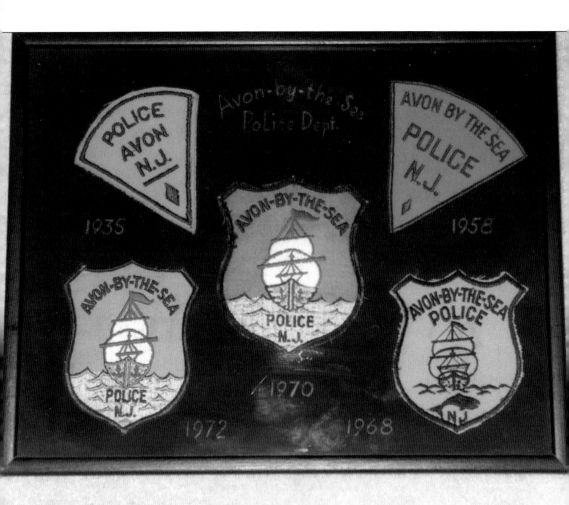

These shoulder patches were worn by members of the police department between 1935 and 1968. The logos on the patches were also used on the door of each squad car. In the 1920s, the Avon police salary was $25 per week for six 12-hour days. In 1935, the hours were reduced to eight hours per day, and in 1951, the 40-hour work week became a reality. (Courtesy of Joe Hagerman.)

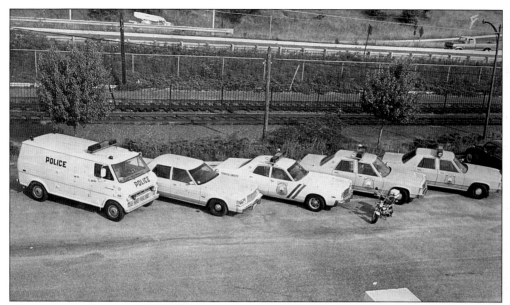

The car unit of the Avon Police Department in the 1970s included the transport van, unmarked detective car, traffic safety car, two patrol vehicles, and a beachfront moped. (Courtesy of Joe Hagerman.)

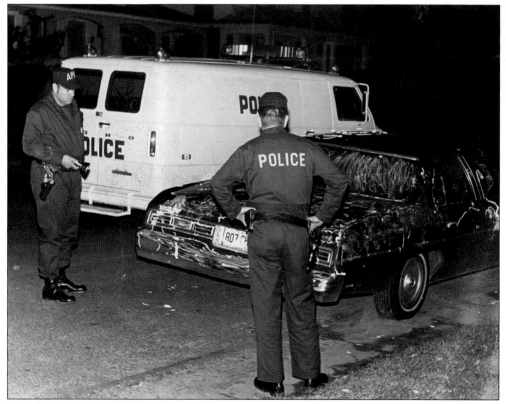

Patrolman Joe Hagerman, left, and Lt. Lloyd Tassey inspect a car that had been "worked over" on Halloween Eve in the 1970s. (Courtesy of Joe Hagerman.)

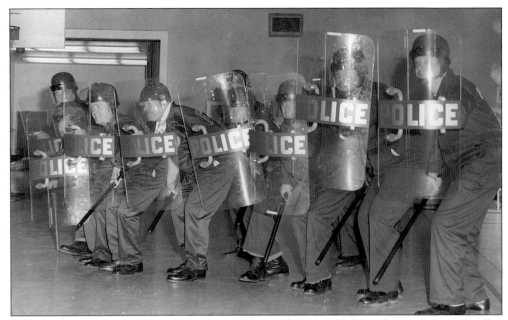

Police practiced riot patrol in full gear in the late 1960s with the police unit from Bradley Beach. The photograph shows Avon officers Chief Tassey, Patrolman Joe Hagerman, Patrolman Bruce Smith, and others. (Courtesy of Joe Hagerman.)

The "Officer for a Day" program was run by the Avon Police Department. In the 1970s, Chief Harry Cuttrell is awarding Kenny Buerck with the honor. The adults pictured are, from left to right, Officer Lonnie Mason, Captain Lloyd Tassey, Sheila Ennis, Officer Jack Carroll, Joanne Barry from the Avon School, Officer Ed Williver, and Sargeant Joe Hagerman. (Courtesy of Joe Hagerman.)

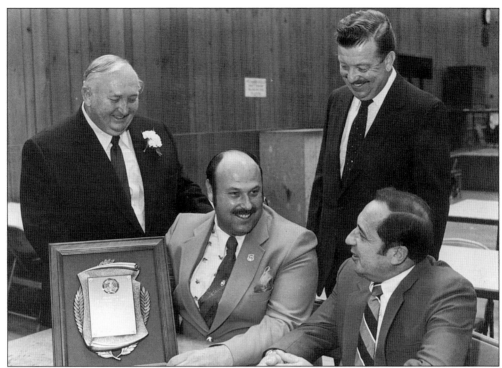

The Police Officer of the Year Award is being presented to Joe Hagerman in the 1980s. Standing is Mr. Palmer, Chairman of the Awards Committee, Chief Tassey, and seated next to Chief Hagerman is Commissioner Andy Saporito. (Courtesy of Joe Hagerman.)

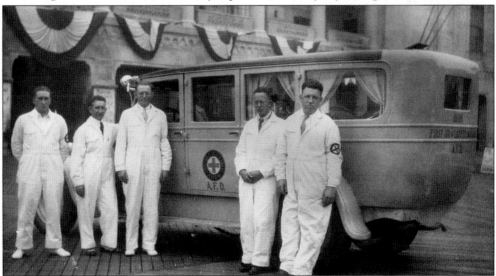

The Avon First Aid Squad was formed by a group of Avon firefighters on October 22, 1931. The squad joined the New Jersey First Aid Council in February 1932. In November of that year, a second-hand hearse was reconditioned into an ambulance and housed in the garage of Casagrande's market. The men in the photograph are standing in front of the "new" vehicle. John Rhodes, second from left, is the only man identified. (Courtesy of the Avon First Aid Squad.)

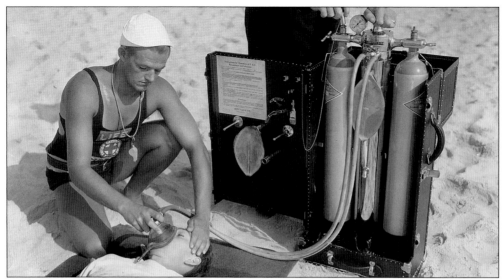

In July 1934, the First Aid Squad purchased a new resuscitator, the first one of its kind to be used in New Jersey. Two months later, the resuscitator would be essential in saving the lives of many of the victims of the Morro Castle. On May 6, 1937, the squad was also called to assist in the *Hindenburg* crash. Charlie Dodd demonstrates the "automatic breather" on the Avon beach. (Courtesy of Raymond Dodd.)

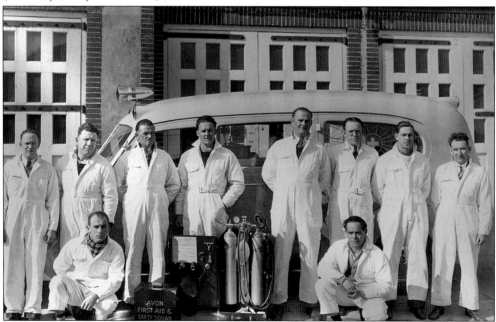

A Cadillac ambulance was purchased for $9,735 in February 1952 and put into service on March 30. The first radio was installed and connected with police headquarters on March 16, 1958. In April 1962, an Oldsmobile ambulance was bought, and the Cadillac went to the newly formed Brielle First Aid Squad for $500. The men standing in front of the 1952 vehicle are, from left to right, Allen Smith, Marvin Mytinger, Charlie Dodd, one unidentified person, Milt Hampton, two unidentified people, and Speed Newman. The two kneeling may be Norman Rhodes and Mervin Smith. (Courtesy of Avon First Aid.)

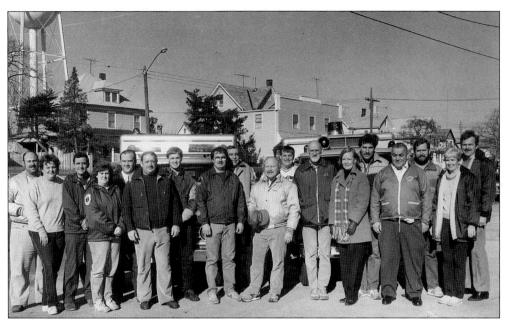

On March 16, 1958, the First Aid Squad moved into its new home on Main Street. The building was dedicated on June 6, 1959. This photograph was taken in the 1970s. Members are, from left to right, Joe Hagerman, Pat Hagerman, Bill Weeden, Tracey Weeden, Tom Hartl, Jerry Hauselt, Andy Leather, Ken Child, Bart Barry, Charlie Hartl, Kelly Hagerman, Art Schroeder, Joanne Barry, Jay Thompson, Mervin Smith, Karl Klug, Jane Connors, and Dennis Gannon. (Courtesy of the Avon First Aid.)

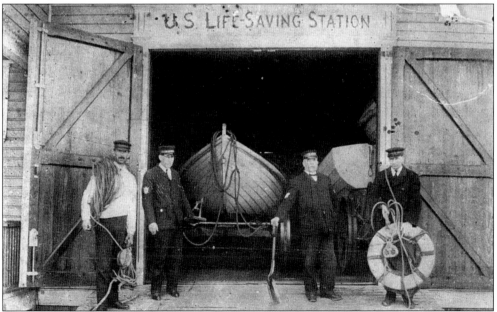

In 1848, the federal government gave the town of Key East (Avon) $10,000 to develop a lifesaving station. The Shark River Lifeboat Station No. Seven was completed in 1849 and commissioned by the U.S. Congress in April 1849. This is how the station looked in 1910. (Courtesy of the Avon Public Library.)

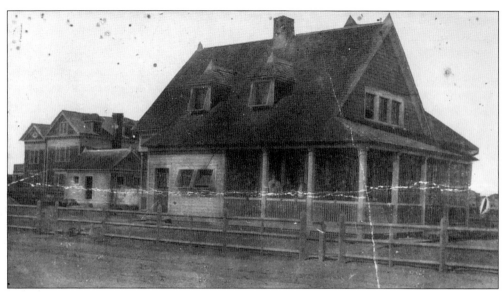

The Lifeboat Station was located at the corner of East End and Ocean Avenues with a boat basin at the Shark River Inlet near Washington Avenue. The station was equipped with one rowboat, rope, some buoys, and several courageous men. (Courtesy of the Avon Public Library.)

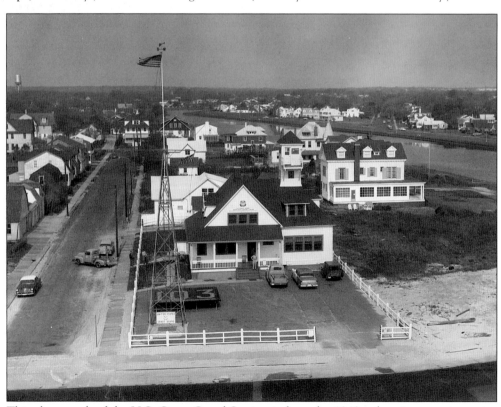

This photograph of the U.S. Coast Guard Station is from the 1940s when it was quite active during WWII. This station was razed in 1967 and moved to more modern facilities built on the site of the old boat basin at the Shark River. (Courtesy of Mayor Jerry Hauselt.)

Young Charlie Dodd poses in his Coast Guard uniform. He is the last living charter member of the Avon First Aid Squad. He now lives in Tom's River but continues to be a wealth of information on life in Avon. (Courtesy of Raymond Dodd.)

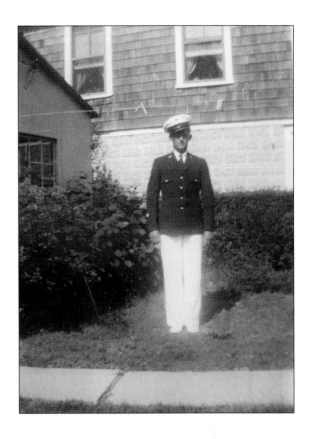

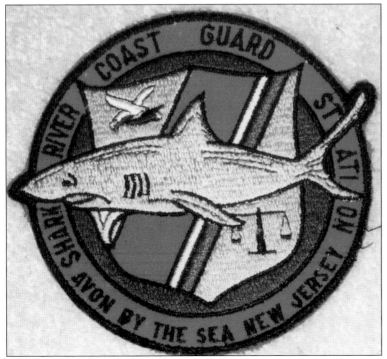

This insignia of the U.S. Coast Guard belonged to Charlie Dodd. The Coast Guard's mission is one of search and rescue missions and law enforcement, covering an area from Long Branch to Sea Girt, including Shark River. (Courtesy of Raymond Dodd.)

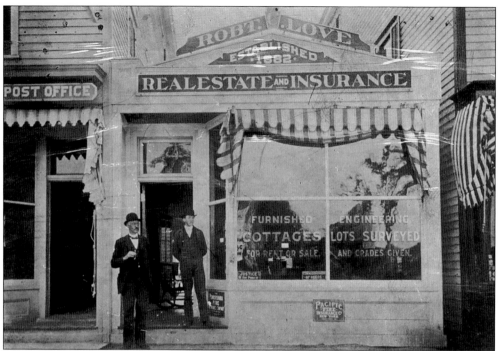

This is the original (1875) Neptune Post Office, which was located in Key East. When the borough was incorporated in 1900, it left Neptune City without a post office for 57 years. The photograph above is from the late 1800s. The first postmaster was William Laird, appointed on August 4, 1869. (Courtesy of Charles Hartl.)

In later years, the post office moved to Sylvania Avenue and then to its present location on the corner of Main Street and South Station Avenue. There have been many postmasters: Benjamin H. Stanton, 1889; William C. Snyder, 1914; Leroy Sofield, 1922; Alfred Sofield, 1929; Walter S. Clayton, 1929; and James J. Reilly, 1979. In 1981, Charles H. Hartl Jr. was appointed and still serves.

# Seven

# MAIN STREET USA

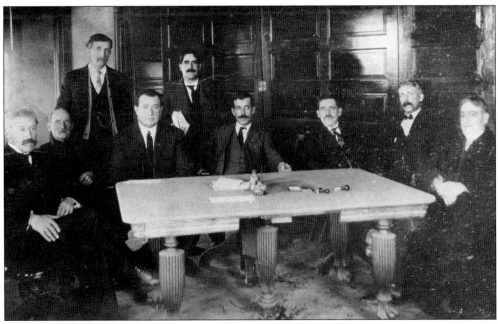

Shown is the Avon Borough Council in 1910. At the time, the council consisted of an elected mayor and six councilmen. This photograph shows Mayor John Thompson and seven others. On the council that year were H.L. Walker, William Synder, A.F. Sofield, M. Brower, G.B. Goodrich, and B.F Herbert. (Courtesy of Bill Dalton.)

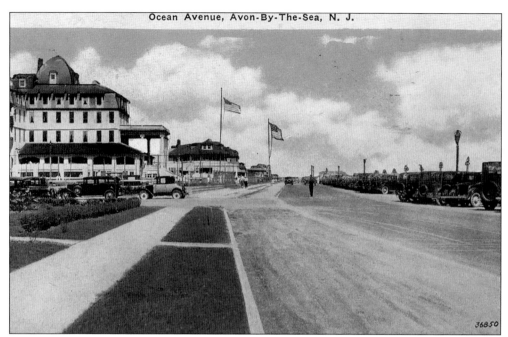

Ocean Avenue, pictured here in the 1920s, could have been considered "Main Street" at the time. The unpaved road was well traveled, with a crossing guard to facilitate treks from the beach to the boardwalk. Traffic on the road is still heavy today, and Avon continues to provide beachfront parking free of charge for its vacationers. (Courtesy of Jane Gannon.)

The house on the corner of Washington and Fifth Avenues, pictured in 1911, was built the same year and has been owned by the Ligo family since 1940. A garage and an apartment were added in the 1920s, but it has remained unchanged since. Note the Avon Public School in the background. (Courtesy of Marianne Stauch.)

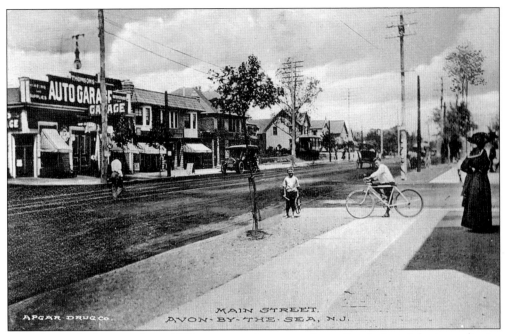

Main Street, looking south in 1906, was once known as Stone Road. Avon's business district has changed little in appearance. Thomson's Auto Garage was open for business when cars and horse-carriages were sharing the road. (Courtesy of Jane Gannon.)

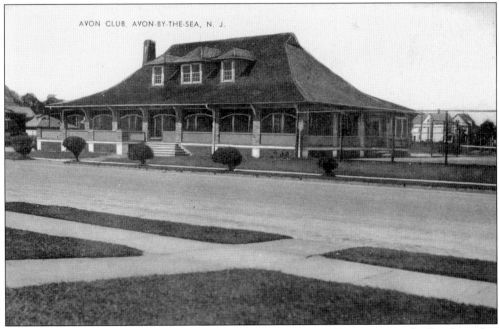

The Avon Club was located next to the Avon Inn on Garfield Avenue, and offered its elite members a variety of social amenities. Today, it is a private home. (Courtesy of Jane Gannon.)

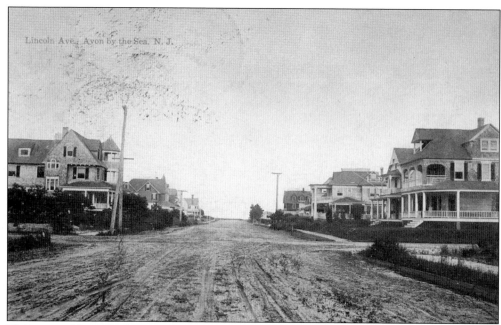

This view of Lincoln Avenue, looking east from Fourth Avenue around 1911, boasts a clear view of the ocean. Huge Victorian-style homes with sprawling porches dominated the block. (Courtesy of Michael Avon Pharmacy)

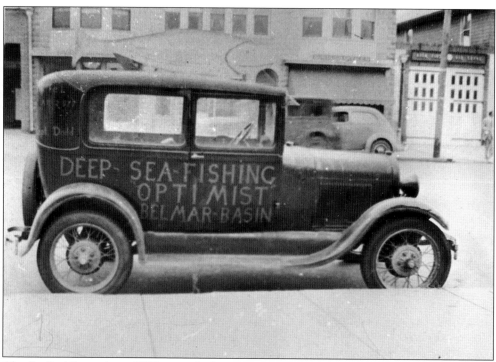

Charlie Dodd's truck, c. 1938, is parked on Main Street across from Thomson's Garage. His business is clearly advertised on the side of the vehicle. (Courtesy of Raymond Dodd.)

This picture was taken in September 1921 on the front porch of 435 Garfield Avenue. Pictured standing are, from left to right, John Talcott Hilton, father of Barbara Hilton Knubbert; Ella Talcott Hilton, David Holden Hilton (John Talcott Hilton's mother and father); and William Holden Hilton (John's brother). Pictured seated are, from left to right, Matilda Holden Hilton and John A. Hilton (John Talcott Hilton's grandparents, Mrs. Knubbert's great-grandparents). (Courtesy of Mr. and Mrs. C. Knubbert and Mrs. E. Hilton.)

In 1921, David Hilton was building the house at 435 Garfield Avenue for his wife, Ella Talcott Hilton, because she loved the shore and the ocean. It has been in the family ever since. Today, Elizabeth Hilton, the wife of one of the sons of David and Ella, John Hilton, lives in the house. Also residing there are Mrs. Hilton's daughter, Barbara Hilton Knubbert, her son-in-law, Charles, and their two children, Charles Jr. and Christine. These last two represent the fourth generation of the family to live in the house. The Avon Library can be seen to the right. (Courtesy of Mr. and Mrs. Charles Knubbert and Elizabeth Hilton.)

Shown is the completed house in September 1921 at 435 Garfield Avenue. (Courtesy of Mr. and Mrs. Charles Knubbert and Elizabeth Hilton.)

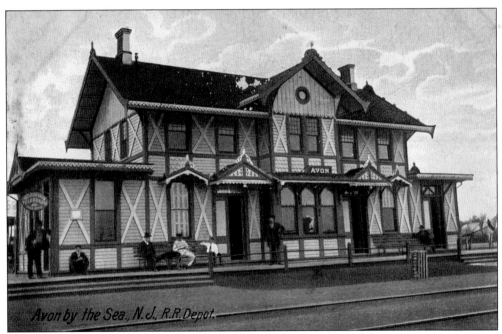

In the early 1900s, the Avon Railroad Station was located on the site of the Municipal Building on Main Street. In Robert Love's real estate brochure, he describes the train service: "Avon is within easy access of both New York and Philadelphia. The time in ordinary transit is about two hours." Rates in the 1920s ranged from $31 for a monthly pass to $65 for 150 trip tickets. (Courtesy of Jane Gannon.)

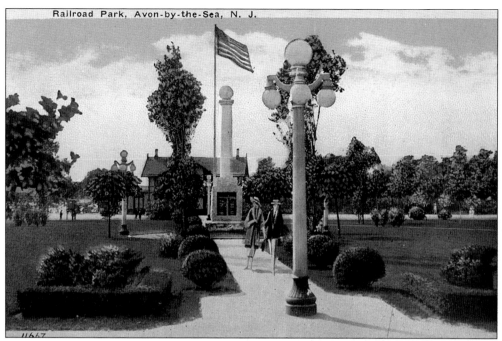

This is how Railroad Park on Main Street looked in 1922. The WWI Monument stood at the center of the park. In the background, the railroad station can be seen. The park, which is now Thomson Square (named for the former Mayor John Thomson) is the setting for the Municipal Building. (Courtesy of Tina Ventimilia.)

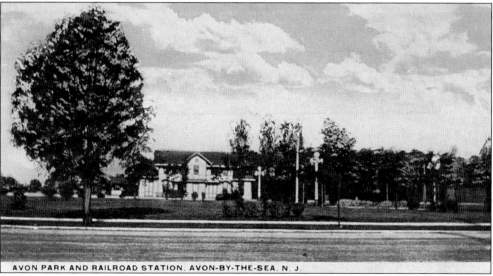

AVON PARK AND RAILROAD STATION, AVON-BY-THE-SEA, N. J.

Train service to Avon was eliminated in the 1970s. Avon commuters traveled to Belmar or Bradley Beach for service. The railroad station was razed in the early 1960s to make way for the Municipal Complex. According to the *Asbury Park Press* of April 21, 1967, "reconstruction of a new station was part of the agreement under which Avon purchased land for the new hall from the New York and Long Branch Railroad (now NJ Transit North Jersey Coast Line)." A small station was built in the rear of the new building but was closed when service to Avon ended. (Courtesy of Tina Ventimilia.)

115

On March 23, 1967, the 67th anniversary of the town, the new Municipal Complex was dedicated. The building serves as the recreation and business center of the borough. The gym is used by the school, and all of the civic groups in town as a meeting area.

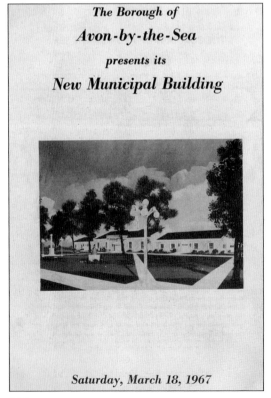

*The Borough of*

*Avon-by-the-Sea*

*presents its*

*New Municipal Building*

*Saturday, March 18, 1967*

The formal dedication of the new Municipal Building was on March 23, but the program to celebrate the event was on Saturday March 18, so that the community could come together and participate in the event. (Courtesy of Dorothy Gallagher.)

This photograph is of an Avon Day Parade held in the 1940s on Main Street. The Viking ship commemorates the legend of Nels Avoné, the mythical Norseman who discovered the borough. (Courtesy of Dorothy Gallagher.)

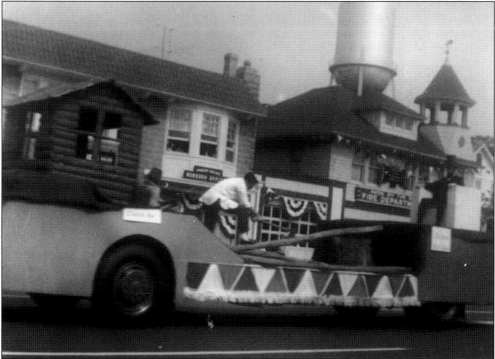

Another float from the parade from the 1940s came complete with log cabin and a mannequin of Abraham Lincoln, representing the residents of Lincoln Avenue. Behind the float, the old firehouse and First Aid Station can be seen. (Courtesy of Dorothy Gallagher.)

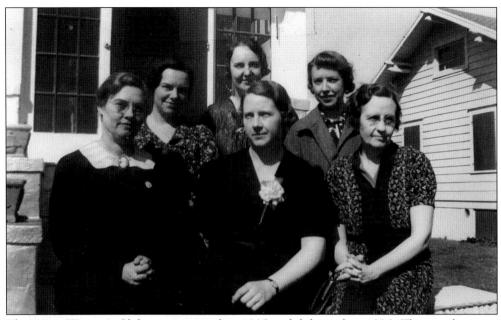

The Avon Woman's Club was organized in 1935 and federated in 1936. The members met on the second Thursday of the month from September to June. Pictured here is the executive board. (Courtesy of the Avon Woman's Club.)

THE WOMAN'S CLUB

OF

AVON-BY-THE-SEA

CONSTITUTION

and

BY-LAWS

The Woman's Club initially met in the home of Mrs. Estelle Whitlock on Garfield Avenue, then in the firehouse meeting room. From there, they took over the old Avon Post Office, which is now Country-by-the-Sea. Today, the club meets at Bedrock Café on the first Monday of every month. The club's constitution is pictured on the left. (Courtesy of the Avon Woman's Club.)

The club published an annual yearbook that listed members, officers, activities for each month, and a memorial for deceased members. (Courtesy of the Avon Woman's Club.)

THE WOMAN'S CLUB
YEAR BOOK

AVON BY THE SEA NEW JERSEY

1937
1938

The Woman's Club was responsible for many entertaining musical performances for the community. Pictured are members of a musical revue, from left to right, Betsy Beckman, piano; Ernestine Naylor, vocalist; Janet Havens, piano; and Joan Symthe, trumpet. (Courtesy of the Avon Woman's Club.)

Pat and Ceil Kennedy are pictured in front of 100 Norwood Avenue in 1931. (Courtesy of Mrs. Buerck.)

During the winter of 1950, a small plow does its duty on the sidewalk. The borough's public works department plows sidewalks during the winter due to the large number of unoccupied summer residences in Avon. (Courtesy of Raymond Dodd.)

In the 1920s, the trolley was a familiar site in Avon and offered eight-minute service from Avon to Asbury Park. On July 15, 1901, an ordinance was passed regulating trolley speed to six miles per hour. (Courtesy of Olive Apicelli.)

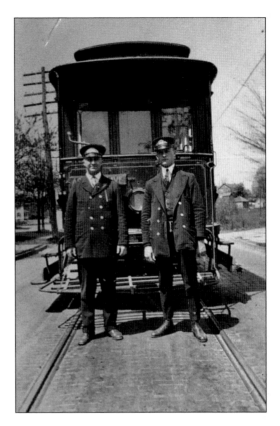

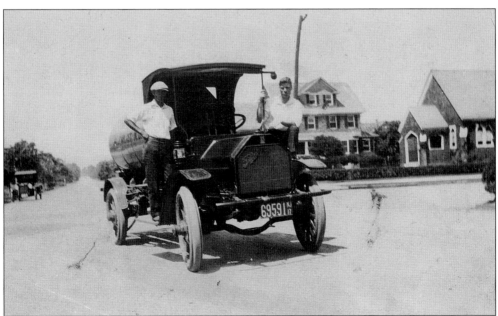

The public works truck in 1917 would spray the streets with saltwater and then scrape them clean to make way for vehicles. On its way east on Woodland Avenue, the truck passes St. John's Episcopal Church. (Courtesy of Raymond Dodd.)

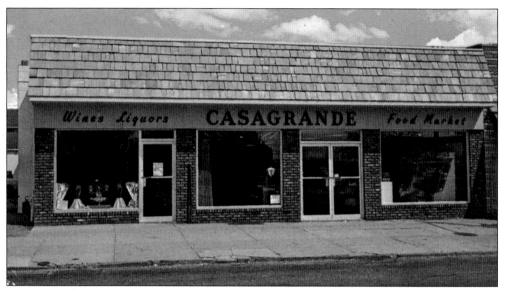

Casagrande's market opened for business in 1922, selling groceries and offering a delivery service for customers twice a week until the 1970s. After WWII, the store was known as United Grocers, only to revert to its original name a few years later. (Courtesy of Charlie and Marie Casagrande.)

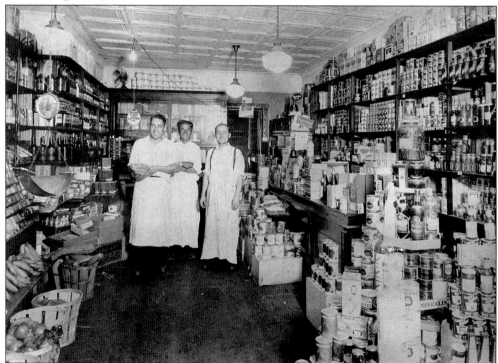

Shown is Casagrande's market as it looked in the 1930s, when only food products were sold. In 1944, the store began to sell liquor and holds the only year-round liquor license in the borough. Pictured are, from left to right, Charles Casagrande (owner), his uncle George Casagrande, and an unidentified employee. (Courtesy of Charles and Marie Casagrande.)

The first official newspaper of the borough was the *Seaside Key Note*, first published in 1883. The paper was published each summer for four years and contained three columns of general news on the front page. In the early 1900s, the *Avon Journal* took over highlighting local events and personalities. (Courtesy of Dorothy Gallagher.)

# THE AVON JOURNAL

Vol. 10 No. 8 | Saturday, September 4, 1926 | Price 3 Cents

## HARRIS' BIRD WINS 100 MILE RACE

Avon Pigeon Fancier First Member From City to Defeat Beams.

The Seaboard Homing Pigeon Club of Asbury Park started its series of young bird races last Sunday. The first race was a sport race, two-bird limit, from Wilmington, Del. Weather conditions were ideal for the race.

The winner of this race was James Harris of Avon. This is the first race in which Harris has ever flown any birds, having joined the club in July. Another unique honor goes to Harris, inasmuch as he is the first member of the club from Asbury Park to defeat Ted Beams of Freehold in a 100-mile race. Beams has invariably been the winner of 100-mile races in the past. Harris feels confident now that he can trim Beams at any distance.

The winning bird last Sunday was presented to Harris by Al. Tilton, and was bred from a pair of Tilton's choice breeders. Tilton is very much pleased to think that a bird bred in the "Trail-in-holt" was the first to defeat Beams and Camp Vail in a 100-mile race.

The speed made by the birds follows:

Harris .......... 887.28
Beams .......... 853.63
Camp Vail .......... 830.62
L. Potter .......... 710.13
Comegys .......... 668.39
Poole .......... 656.95
P. Potter .......... 525.97
A. Tilton .......... no report
C. Eldridge .......... no report
D. White .......... no report

The next race will be held today, and will be a 100-mile club race, 15-bird limit.

Advertise in the Journal

## NEPTUNE GRAMMAR SCHOOL SCHEDULED TO OPEN TUESDAY

Following an active summer of preparation by the faculty and officials, the Neptune City grammar school will open for the new term on Tuesday, Sept. 7, it is announced by William H. Somerville, the principal.

The faculty this year will include the following: Principal and eighth grade, William H. Somerville; seventh grade, Miss Marguerite Allgor; fifth and sixth grades, Miss Esther Boyce; third and fourth grades, Mrs. M. L. Buckingham; second grade, Miss Reva Camburn; first grade, Miss Rebecca Allen, and sub-primary, Miss Elsie Kirkpatrick.

Principal Somerville studied the Winnetka and Dalton plans of individual instruction in a summer course at Rutgers College during the vacation period.

The gymnasium will be ready some time in September and it is planned to hold games of volley ball and indoor soccer there in addition to the basketball games.

The school lawn is as fresh appearing as any in the borough, due to the care of Henry Fleming, the school janitor.

Mr. Somerville plans to have the alumni take an active part in the school activities. A meeting will be held in September for the purpose of bringing members of the alumni together.

## THE PINK EDITION
## WATCH FOR IT!

Immediately after the Dempsey-Tunney championship bout on September 23, The Avon Journal will issue an extra that will contain all the results, and a description of the fight. DON'T MISS IT.

The Avon Public Grammar School will open on or about Monday, September 20, according to a statement issued yesterday.

## AVON FIREMEN'S TAG DAY TODAY

Hope to Beat Last Year's Record of Receipts for Tags.

The Avon Volunteer Fire Department are holding their annual tag day today. At various points all over the borough the agents and workers of the companies await you. Do not pass them by. Remember that 365 days in the year these men, volunteers, are at your disposal upon a moment's notice. They assume risks in the interests of protecting your property. This is a worthy cause and the firemen will appreciate any contribution that is made. Last year was the first time that the local department held a tag day and they met with such fine co-operation from the residents of this borough that they again ask you to help.

### PURCHASES NEW CAR

Chief of Police John L. Hart has purchased a new Ford roadster, according to a statement issued by the Chief yesterday. The car is to be equipped with overhead valves, so that it can be used to catch speeders.

*After next weeks issue a subscription rate of $1.00 per year will be charged or 3 cents a copy. Paper mailed to your address for this amount.*

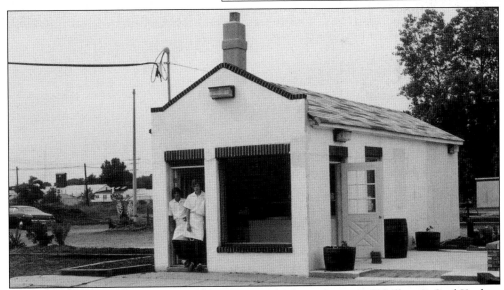

Schneider's Ice Cream Depot, shown in 1978, was built on the site of Hoffman's Coal Yard on Railroad Avenue—a site that also served as a trucking weigh station. In the 1970s, the land was bought by the Schneider family. The depot was part of Schneider's restaurant. Pictured above are Hans Schneider and his friend, Ed Monacchio. Rumor has it that Perry Como would stop in after a performance at the Garden State Arts Center for homemade ice cream. (Courtesy of the Schneider Family.)

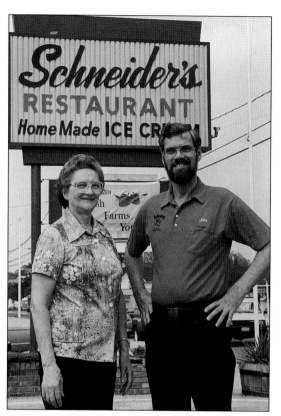

Mr. and Mrs. Peter Schneider's restaurant is located at 801 Main Street and opened in the 1970s as an ice cream parlor with a limited menu. When the restaurant expanded its menu and space, it soon became a popular eatery and an Avon tradition. After the death of Mr. Schneider in 1975, his wife and his son John, a research chemist and avid balloonist, managed the restaurant, serving home-cooked meals, German specialties, and ice cream. Pictured under the sign are Mrs. Theresa Schneider and John, who serves as president of the Avon Business Community. (Courtesy of the Schneider Family.)

Timothy Gallagher was born in 1950 at Fitkin Hospital in Neptune. A lifelong resident of Avon, he graduated from Avon Grammar School, CBA, and Villanova. He has been beach supervisor and chief lifeguard, now serving as borough administrator and clerk. He also serves as the captain of the First Aid Squad and has been involved in scouting since 1961. He and Bill Herbert were the first Eagle Scouts from Troop 89. He is married to Elise and has two children, Matthew and Edith. (Courtesy of the Avon Public Library.)

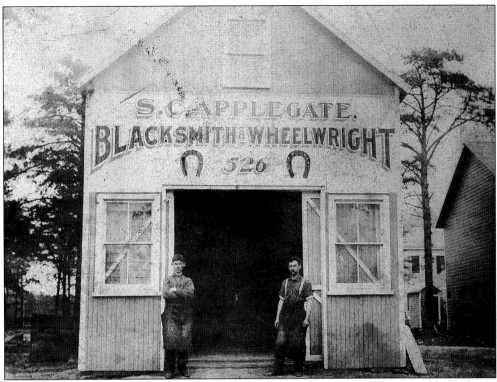

The Applegates are in front of their new shop on 526 Main Street. Today, there is a gourmet deli on the site. (Courtesy of Charles Hartl.)

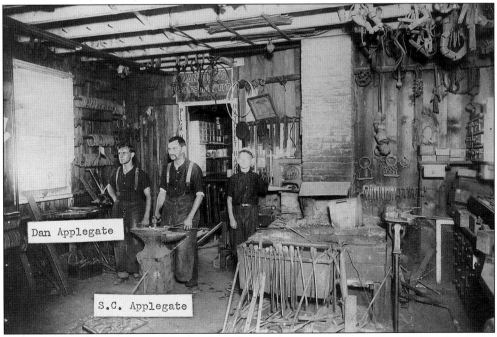

Dan Applegate

S.C. Applegate

The interior of the Applegates' shop is shown with its owners and an unidentified worker in the early 1900s. (Courtesy of Charles Hartl.)

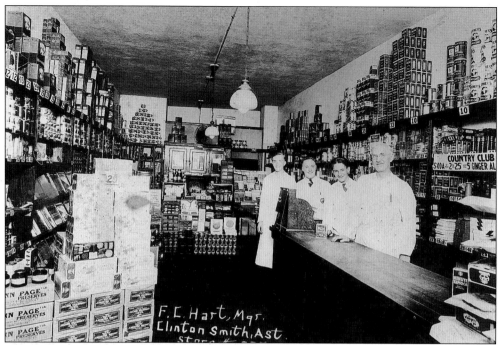

The A&P market was located at 420 Main Street in the 1920s. A young Tom Child can be seen here with the store managers. (Courtesy of Ann Child.)

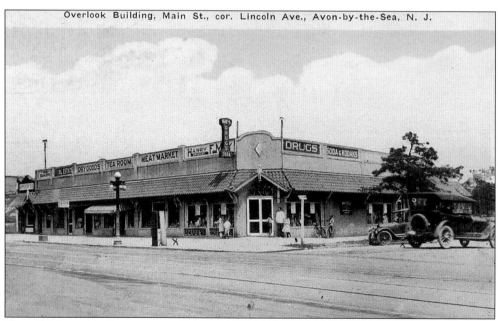

Harry F. May was a pharmacist and inventor who came to Avon in 1888. He patented a pill for indigestion. The pills were called "Maypinks" because they were pink in color, and were touted as "the magic tablet for nerves and all forms of indigestion and gas." He opened business at 300 Main Street in the early 1900s and named the store Maypinks, "a drugstore with a conscience." Today, the store operates as the Avon Pharmacy. (Courtesy of Michael, Avon Pharmacy.)

Mayor Jerry Hauselt (seated) signs the proclamation commemorating the Centennial of Avon-by-the-Sea. Standing are Commissioner Joe Hagerman, Borough Administrator Tim Gallagher, and Commissioner William Dioguardi. (Courtesy of Mayor Jerry Hauselt.)

**Borough of Avon-by-the-Sea**
301 Main Street
New Jersey
07717

JERRY HAUSELT, MAYOR
DIRECTOR OF PUBLIC AFFAIRS & SAFETY

WILLIAM P. DIOGUARDI, COMMISSIONER
DIRECTOR OF REVENUE & FINANCE

JOSEPH W. HAGERMAN, SR., COMMISSIONER
DIRECTOR OF PUBLIC WORKS

AREA CODE
732-502-4510

FAX 732-774-0605

TIMOTHY M. GALLAGHER
BOROUGH CLERK/ADMINISTRATOR

DEAR FRIENDS,

AVON-BY-THE-SEA IS A WONDERFUL SMALL TOWN THAT OFFERS ALL THE FRIENDSHIPS, CHARM AND OPPORTUNITIES THAT OUR RESIDENTS AND VISITORS HAVE COME TO DESIRE FOR NEARLY 100 YEARS. IT HAS BEEN WRITTEN THAT "AVON-BY-THE-SEA IS THE BEST KEPT SECRET AT THE JERSEY SHORE". THE PHOTOS, FACTS AND COLORFUL COMMENTARY IN THIS HISTORICAL COLLECTION HAVE BEEN GATHERED TO PROVIDE SOME UNIQUE IN-SIGHTS AS TO WHO WE ARE AS A BOROUGH AND HOW WE WORKED TO BUILD THIS BOROUGH INTO THE BEST KEPT SECRET AT THE JERSEY SHORE.

I AM VERY APPRECIATIVE OF ALL THE EFFORTS THAT SO MANY PERSONS PUT FORTH TO MAKE THIS BOOK POSSIBLE. ENJOY THE HISTORY AND BECOME A PART OF OUR FUTURE.

VERY SINCERELY,

*Jerry Hauselt*

JERRY HAUSELT, MAYOR

# Bibliography

*Asbury Journal.* June 20, 1899.

*Asbury Park Evening Press.* July 23, 1965.

*Asbury Park Press.* December 20, 1992.

Cottrell, Richard F. *A Centennial History.* Neptune City, NJ: TFH Publications Inc., 1981.

Eckler, Robert N., assisted by Arthur A. Dunham and Joan M. Dunham. *Memories of Avon-by-the-Sea.* The Avon Bicentennial Committee, 1975.

Gagen, James T., ed. *History of Avon-by-the-Sea.* From *The Avon Journal,* Avon, NJ, 1920s

Love, Robert C. *In a Cottage at Avon-by-the-Sea.* Avon Real Estate Offices, Avon, NJ, (reproduced 1998).

Martin, S., and George Castor. *The Shark River District Genealogic 1914.* Asbury Park, NJ: Martin and Allardyce.

Nelson, William, ed. *The New Jersey Coast: Three Centuries' History of the New Jersey Coast with Genealogical and Historic and Biographical Appendix;* (Illustrated Vol. III.) New York and Chicago: Lewis Publishing Company, 1920.

Quinn, John R. *One Square Mile on the Atlantic Coast: An Artists' Journal of the New Jersey Shore.* New York: Walker and Company, 1993.

In Celebration

For one hundred years our witness was made
To the matin's sweet kiss upon night's yielding shade,
To the tides gentle touch, the stray gull's silent wave
Another day's dawn on legacy saved.
Saved in the salt scented silent repose,
In the whispers that only the beachcomber knows;

Telling tales of the ocean on our soft shore,
Of calm summer nights, of storm's mighty roar,
Of the blessing and challenge bestowed on the land,
The silent and steady embrace of God's hand,
Remembered in each morning's spellbinding kiss,
The slight chill of wonder, the dawn's silky mist;

Recalled in the rhythms of each passing tide,
Each child's playful laughter, each surfer's sweet ride,
In each board walker's step, each fisherman's sigh,
Each young lover's touch, in the eager reply,
The Grace of the past and what's still yet to be
In Avon, where God joins mere man with His sea.
—Michael Musante